天守物語

泉鏡花作

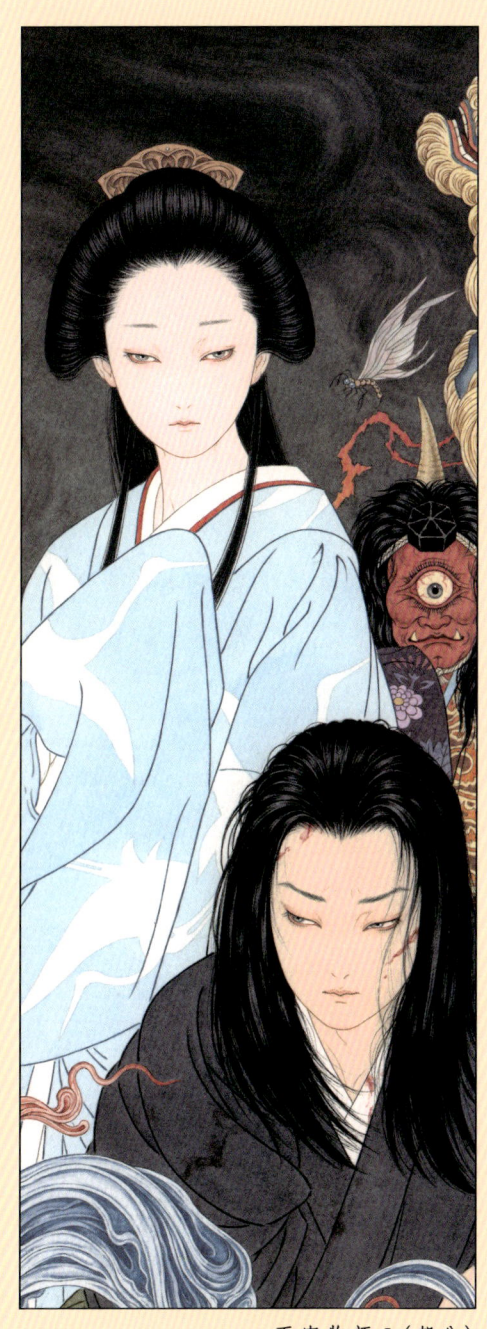

天守物語Ⅰ（部分）

目次

天守物語　　　　　　　　　　　三

解説　　穴倉玉日　　　　　　　七七

本画　　　　　　　　　　　　　九五

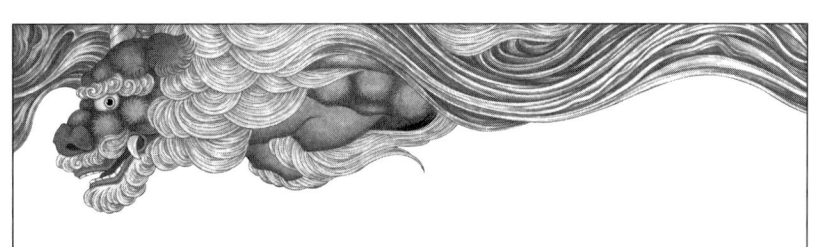

天守物語

作　泉鏡花
画　山本タカト

天守物語

時　　不詳。ただし封建時代――晩秋。日没前より深更にいたる。

所　　播州姫路。白鷺城の天守、第五重。

登場人物

天守夫人、富姫。（打見は二十七、八）岩代国猪苗代、亀の城、亀姫。（二十ばかり）

姫川図書之助。（わかき鷹匠）小田原修理。山隅九平。（ともに姫路城主武田播磨守家臣）

十文字ヶ原、朱の盤坊。茅野ヶ原の舌長姥。（ともに亀姫の眷属）近江之丞桃六。（工人）

桔梗。萩。葛。女郎花。撫子。（いずれも富姫の侍女）薄。（おなじく奥女中）女の童、

禿、五人。武士、討手、大勢。

舞台。天守の五重。左右に柱、向って三方を天井の如く余して、一面に高く高麗べりの畳を敷く。紅の鼓の緒を廻廊下の如く取りまわして柱に渡す。おなじく鼓の緒のひかえなにて、向って右、廻廊の奥に階子を設く。階子は天井に高く通ず。左の方廻廊の奥に、また階子の上下の口あり。奥の正面、及び右なる廻廊の半ば厚き壁にて、広き矢狭間、狭間を設く。外面は山嶽の遠見、秋の雲。壁に出入りの扉あり。鼓の緒の欄干外、左の一方、棟甍、並びに樹立の梢を見す。正面おなじく森々たる樹木の梢。

女童三人——合唱——

天神様の細道じゃ、
此処は何処の細道じゃ、細道じゃ、

——うたいつつ幕開く——

侍女五人。桔梗、女郎花、萩、葛、撫子。各名におぐえる姿、鼓の緒の欄干に、あるいは立ち、あるいは坐して、手に手に五色の絹糸を巻きたる糸枠に、金色銀色の細き棹を通し、糸を松杉の高き梢を潜らして、釣の姿して。

女童三人は、緋のきつけ、唄いつづく。——冴えてかつ寂しき声。

少し通して下さんせ、下さんせ。
ごようのないもな通しません、通しません。

薄　　天神様へ願掛けに、願掛けに。
　　　通らんせ、通らんせ。
　　　唄いつつその遊戯をす。
　　　薄、天守の壁の裡より出づ。壁の一劃はあたかも扉の如く、自由に開く、この婦やや年かさ。鼈甲の突通し、御殿奥女中のこしらえ。
　　　鬼灯さん、蜻蛉さん。

女童一　ああい。

薄　　静になさいよ、お掃除が済んだばかりだから。

女童二　あの、釣を見ましょうね。

薄　　（四辺を睗す）これは、まあ、まことに、いい見晴しでございますね。

女童三　そうね。

　　　いたいけに頷きあいつつ、侍女らの中に、はらはらと袖を交う。

葛　　あの、猪苗代のお姫様がお遊びにおいででございますから。

桔梗　お鬱陶しかろうと思いまして。それには、申分のございませんお日和でございますし、遠山はもう、もみじいたしましたから。

女郎花　矢狭間も、物見も、お目触りな、泥や、鉄の、重くるしい、外囲は、ちょっと取払って

薄
　置きました。

薄
　なるほど、なるほど、よくおなまけ遊ばす方たちにしては、感心にお気のつきましたことでございます。

桔梗
　あれ、人ぎきの悪いことを。——いつ私たちがなまけましたえ。

薄
　まあ、そうお言いのではあるまいし、お天守の五重から釣をするものがありますかえ。天の川は芝を流れはいたしません。富姫様が、よそへお出掛け遊ばして、いくら間があると申したって、串戯ではありません。

撫子
　否、魚を釣るのではございません。

桔梗
　旦那様の御前に、丁ど活けるのがございませんから、皆で取って差上げようと存じまして、花を……あの、秋草を釣りますのでございますよ。

薄
　花を、秋草をえ。はて、これは珍しいことを承ります。そして何かい、釣れますかえ。

桔梗
　ええ、釣れますとも、尤も、新発明でございます。女童の一人の肩に、袖でつかまって差覗く。

薄
　高慢なことをお言いでない。——が、つきましては、念のために伺いますが、お用になります。……餌の儀でござんすがね。

撫子
　はい、それは白露でございますわ。

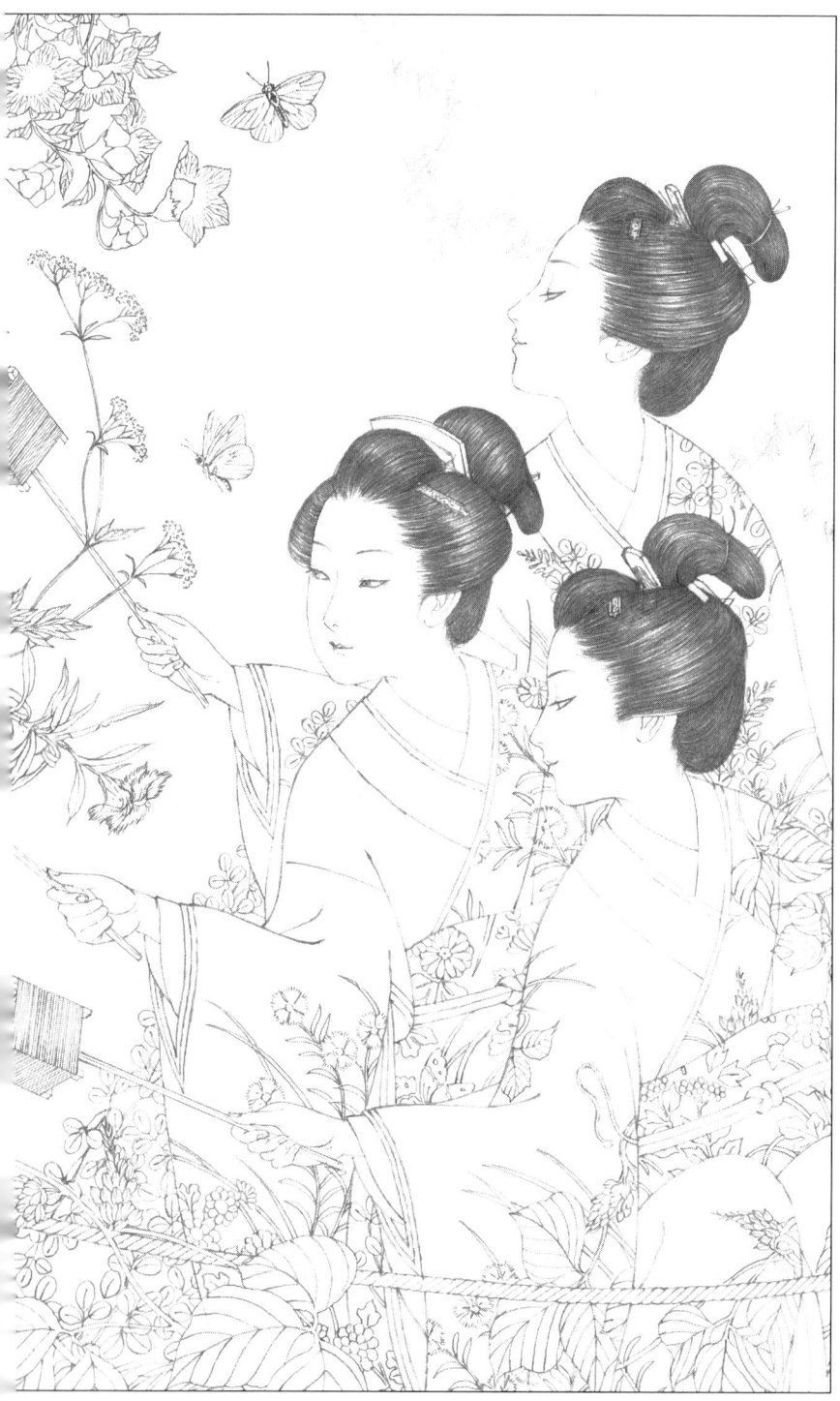

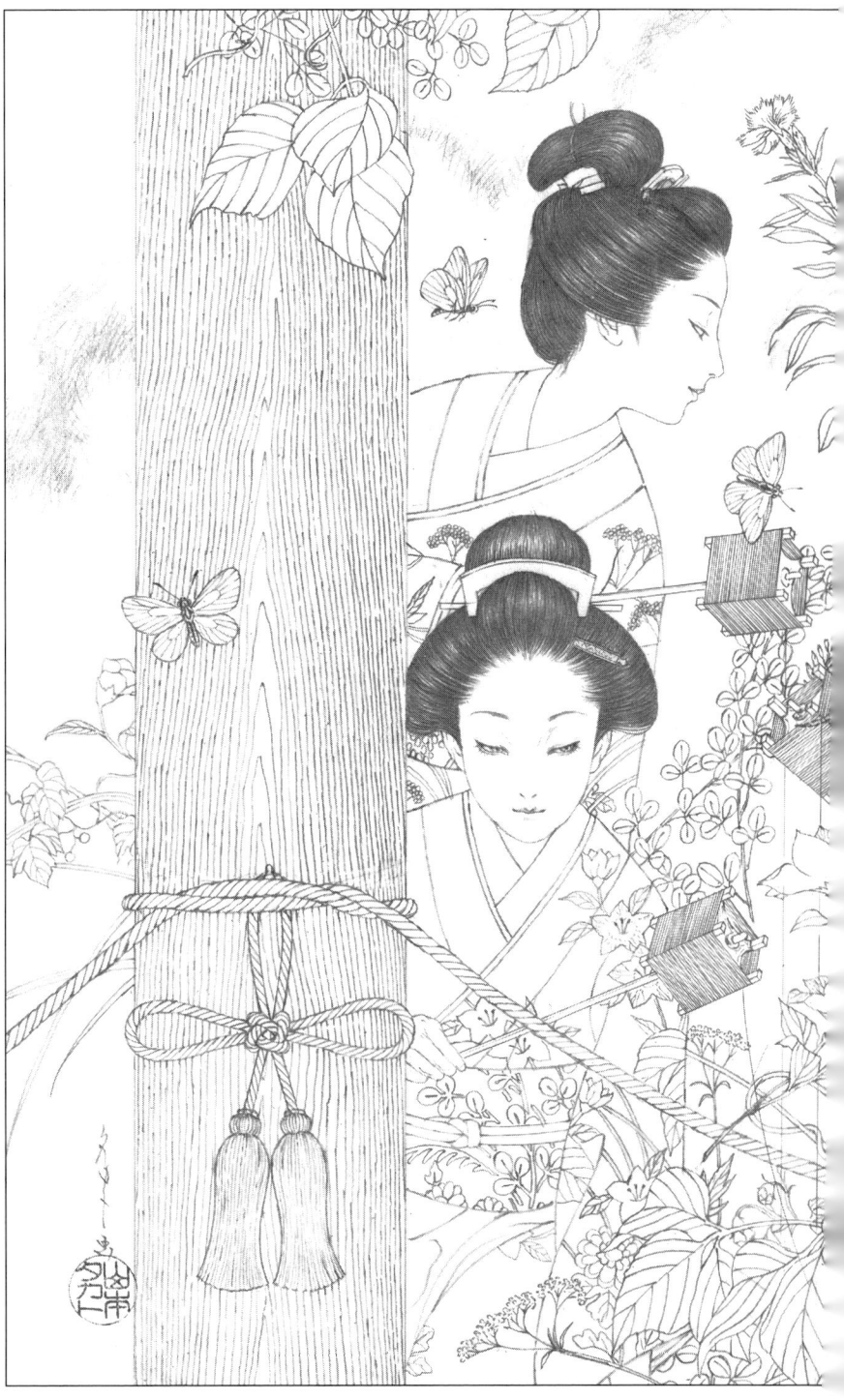

葛　千草八千草秋草が、それはそれは、今頃は、露を沢山欲しがるのでございますよ。刻限も七つ時、まだ夕露も夜露もないのでございますもの。（隣を視る）御覧なさいまし、女郎花さんは、もう、あんなにお釣りなさいました。

薄　ああ、真個にねえ。まったく草花が釣れるとなれば、女郎花さんがよく釣った、争われないものじゃないかね。

女郎花　否、お魚とは違いますから、唄いましても構いませんわ。……餌の露が、ぱらぱらこぼれてしまいますから。ああ、釣れました。しましょう。釣をするのに饒舌っては悪いというから。……一番だまっておとなしい女郎花さんがよく釣った、——これは静にして、拝見をいたと不可ませんわ。……餌の露が、ぱらぱらこぼれてしまいますから。ああ、釣れました。

薄　お見事。

　という時、女郎花、棹ながらくるくると棹を巻戻す、糸につれて秋草、欄干に上り来る。さきに傍に置きたる花とともに、女童の手に渡す。

桔梗　釣れました。（おなじく糸を巻戻す。）

萩　あれ、私も……

葛　それそれ私も——まあ、しおらしい。花につれて、黄と、白、紫の胡蝶の群、ひらひらと舞上る。

薄　桔梗さん、棹をお貸しな、私も釣ろう、まことに感心、おつだことねえ。

女郎花　お待ち遊ばせ、大層風が出て参りました、餌が糸にとまりますまい。

薄　意地の悪い、急に激しい風になったよ。

萩　ああ、内廓の秋草が、美しい波を打ちます。

桔梗　そういううちに、色もかくれて、薄ばかりが真白に、水のように流れて来ました。

葛　空は黒雲が走りますよ。

薄　先刻から、野も山も、不思議に暗いと思っていた、これは酷い降りになりますね。

撫子　舞台暗くなる、電光閃く。

薄　夫人は、何処へおいでしたのでございますえ。早くお帰り遊ばせば可うございますね。

萩　平時のように、何処へとも何ともおっしゃらないで、ふいとお出ましになったもの。

薄　お迎いにも参られませんねえ。

葛　お客様、亀姫様のおいでの時刻を、それでも御含みで在らっしゃるから、ほどなくお帰りでございましょう。——皆さんが、御心入れの御馳走、何、秋草を、早くお供えなさるが可いね。

女郎花　それこそ露の散らぬ間に。——

　正面奥の中央、丸柱の傍に鎧櫃を据えて、上に、金色の眼、白銀の牙、色は藍の如き獅子頭、萌黄錦の母衣、朱の渦まきたる尾を装いたるまま、荘重にこれを据えたり。——侍女ら、女童とともにその前に行き、跪きて、手に手に秋草を花籠に挿す。色のその美しき蝶の群、斉く飛連れてあたりに舞う。

薄　雷やや聞ゆ。雨来る。

桔梗　（薄暗き中に）御覧、両眼赫燿と、牙も動くように見えること。花も胡蝶もお気に入って、お嬉しいんでございましょう。

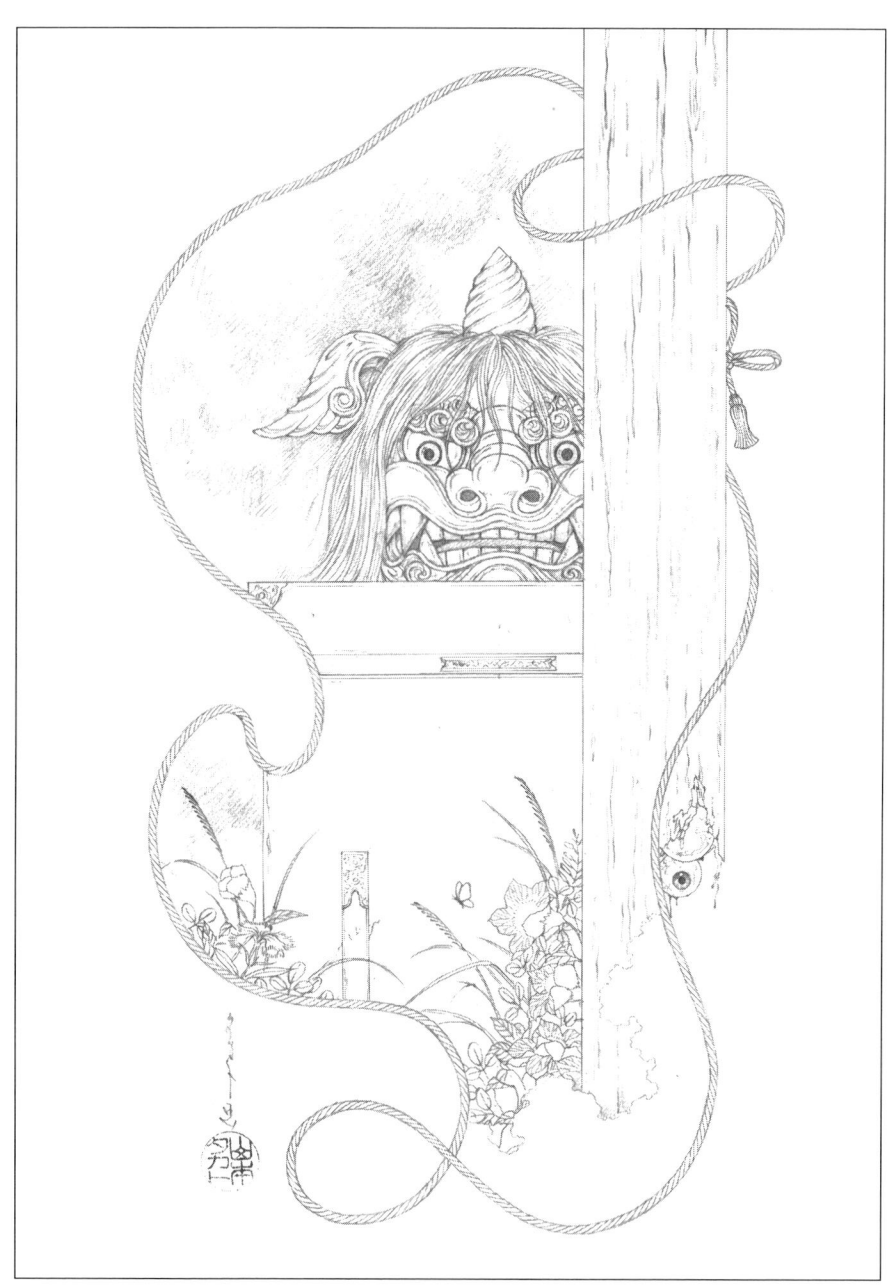

時に閃電す。光の裡を、衝と流れて、胡蝶の彼処に流るる処、殆ど天井を貫きたる高き天守の棟に通ずる階子。――侍女ら、飛ぶ蝶の行方につれて、ともに其方に目を注ぐ。

女郎花　あれ、夫人がお帰りでございますよ。

はらはらとその壇の許に、振袖、詰袖、揃って手をつく。階子の上より、先ず水色の衣の裾、裳を引く。すぐに蓑を被ぎたる姿見ゆ。長なす黒髪、片手に竹笠、半ば面を蔽いたる、美しく気高き貴女、天守夫人、富姫。

夫人　（その姿に舞い縺る蝶々の三つ二つを、蓑を開いて片袖に受く）出迎えかい、御苦労だね。（蝶にいう。）

――お帰り遊ばせ、――お帰り遊ばせ――侍女ら、口々に言迎う。――

夫人　時々、ふいと気まかせに、野分のような出歩行きを、……ハタと竹笠を落す。女郎花、これを受け取る。貴女の面、凄きばかり白く艶長けたり。露も散らさぬお前たち、花の姿に気の毒だね。（下りかかりて壇に弱腰、廊下に裳。）

薄　勿体ないことを御意遊ばす。――まあ、御前様、あんなものを召しまして。

夫人　似合ったかい。

薄　なおその上に、御前様、お痩せ遊ばしておがまれます。柳よりもお優しい、すらすらと雨の刈萱を、お祓け遊ばしたようにございます。

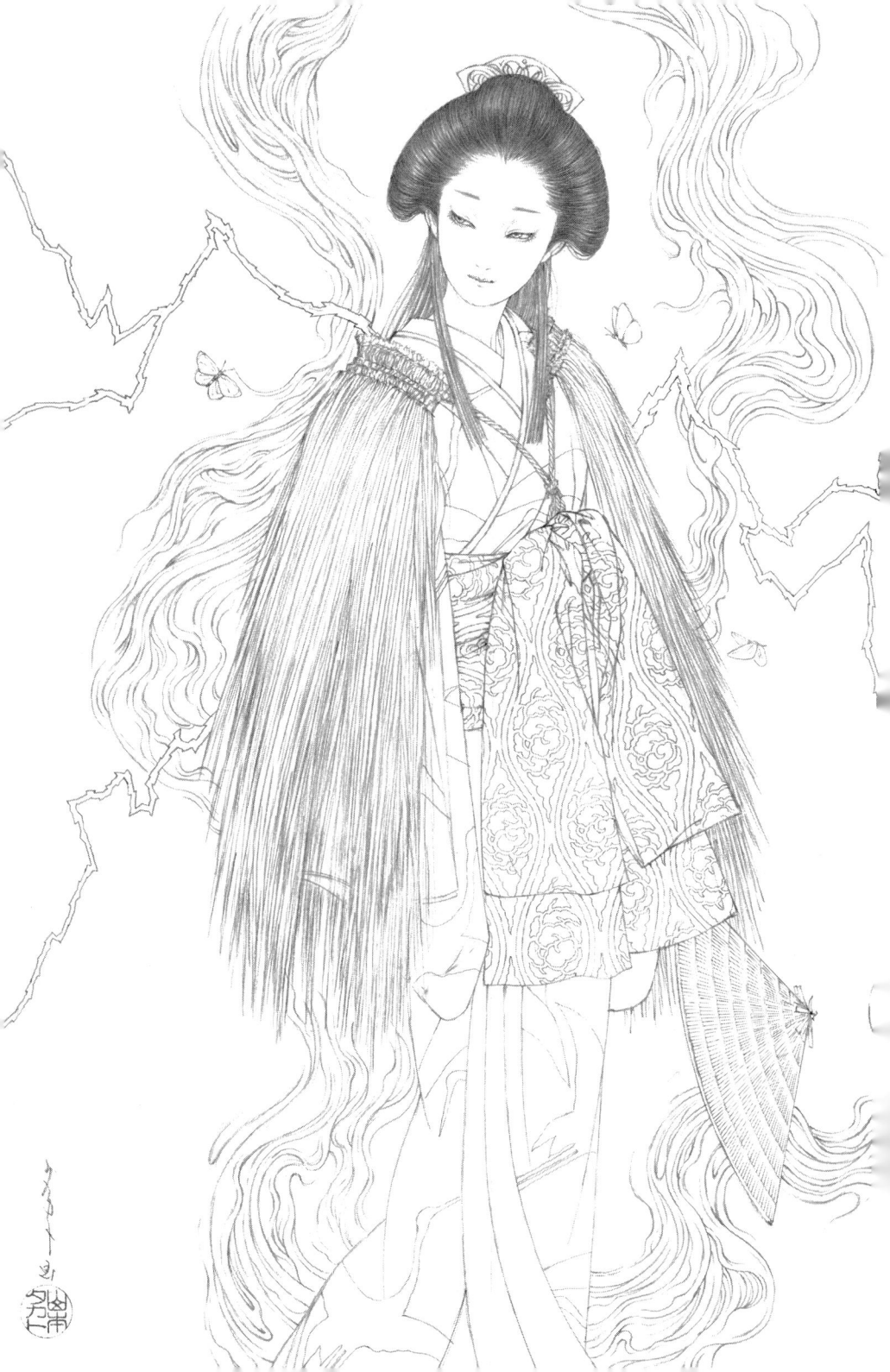

夫人　嘘ばっかり。小山田の、案山子に借りて来たのだものを。

薄　否、それでも貴女がめしますと、玉、白銀、揺の糸の、鎧のようにもおがまれます。

夫人　賞められて些と重くなった。（蓑を脱ぐ）取っておくれ。

撫子、立ち、うけて欄干にひらりと掛く。

蝶の数、その蓑に翼を憩う。……夫人、獅子頭に会釈しつつ、座に、褥に着く。脇息。

侍女たちかしずく。

少し草臥れましたよ。……お亀様はまだお見えではなかったろうね。

薄　はい、お姫様は、やがてお入りでございましょう。それにつけましても、御前様おかえりを、お待ち申上げました。──そしてまあ、いずれへお越し遊ばしました。

夫人　夜叉ヶ池まで参ったよ。

薄　おお、越前国大野郡　人跡絶えました山奥の。

萩　あの、夜叉ヶ池まで。

桔梗　お遊びに。

夫人　まあ、遊びと言えば遊びだけれども、大池のぬしのお雪様に、些と……頼みたい事があって、私はじめ、ここにおります、誰ぞお使いをいたしますもの、御自分おいで遊ばして、何と、雨にお逢いなさいましてさ。

夫人　その雨を頼みに行きました。——今日はね、この姫路の城……ここから視れば長屋だが、……長屋の主人、それ、播磨守が、秋の野山へ鷹狩に、大勢で出掛けました。皆知っておいでだろう。空は高し、渡鳥、色鳥の鳴く音は嬉しいが、田畑と言わず駆廻って、きゃっきゃっと飛騒ぐ、知行とりども人間の大声は騒がしい。まだ、それも鷹ばかりなら我慢もする。近頃は不作法な、弓矢、鉄砲で荒立つから、うるささもうるささ。何よりお前、私のお客、この大空の霧を渡って輿でおいでのお亀様にも、途中失礼だと思ったから、雨風と、はたた神で、鷹狩の行列を追崩す。——あの、それを、夜叉ヶ池のお雪様にお頼み申しにと参ったのだよ。

薄　道理こそ時ならぬ、急な雨と存じました。

この辺は雨だけかい。それは、ほんの吹降りの余波であろう。鷹狩が遠出をした、姫路野の一里塚のあたりをお見な。暗夜のような黒い雲、眩いばかりの電光、可恐しい雹も降りました。鷹狩の連中は、曠野の、塚の印の松の根に、澪に寄った鮒のように、うようよ集って、あぶあぶして、あやい笠が泳ぐやら、陣羽織が流れるやら。大小をさしたものが、些とは雨にも濡れたが可い。慌てる紋は泡沫のよう。野袴の裾を端折って、灸のあとを出すのがある。おお、おかしい。（微笑む）粟粒を一つ二つと算えて拾う雀でも、俄雨には容子が可い。五百石、三百石、千石一人で食むものが、その笑止さと言っては

夫人　ない。おかしいやら、気の毒やら、ねえ、お前。

薄　はい。

夫人　私はね、群鷺ヶ峰の山の端に、掛稲を楯にして、戻道で、そっと立って視ていた。其処には昼の月があって、雁金のように（その水色の袖を圧う）その袖に影が映った。影が、結んだ玉ずさのようにも見えた。——夜叉ヶ池のお雪様は、激しいなかにお床しい、野はその黒雲、尾上は瑠璃、皆、あの方のお計らい。それでも鷹狩の足も腰も留めさせずに、大風と大雨で、城まで追返しておくれの約束。鷹狩たちが遠くから、松を離れて、その曠野を、黒雲の走る下に、泥川のように流れてくるに従って、追手の風の横吹。私が見ていたあたりへも、一村雨颯とかかったから、歌も読まずに蓑をかりて、案山子の笠をさして来ました。

ああ、其処の蜻蛉と鬼灯たち、小児に持たして後ほどに返しましょう。

薄　何の、それには及びますまいと存じます。

夫人　いえいえ、農家のものは大切だから、等閑にはなりません。

薄　その儀は畏りました。お前様、まあ、それよりも、おめしかえを遊ばしまし、おめしものが濡れまして、お気味が悪うござりましょう。

夫人　おかげで濡れはしなかった。気味の悪い事もないけれど、隔てぬ中の女同士も、お亀様に、このままでは失礼だろう。（立つ）着換えましょうか。

女郎花　次手に、お髪も、夫人様。

夫人　ああ、あげてもらおうよ。

　　夫人に続いて、一同、壁の扉に隠る。女童のこりて、合唱す──

此処は何処の細道じゃ、細道じゃ。
天神様の細道じゃ、細道じゃ。

時に棟に通ずる件の階子を棟よりして入来る、岩代国麻耶郡猪苗代の城、千畳敷の主、亀姫の供頭、朱の盤坊、大山伏の扮装、頭に犀の如き角一つあり、眼円かに面の色朱よりも赤く、手と脚、瓜に似て青し。白布にておうたる一個の小桶を小脇に、柱をめぐりて、内を覗き、女童の戯るるを視つつ破顔して笑う。

朱の盤　かちかちかちかち。

　　　　歯を嚙鳴らす音をさす。女童ら、走り近く時、面を差寄せ、大口開く。

　　　　もおう！（獣の吠ゆる真似して威す。）

女童一　可厭な、小父さん。

女童二　可恐くはありませんよ。

朱の盤　だだだだだ。（濁れる笑）いや、さすがは姫路お天守の、富姫御前の禿たち、変化心備わって、奥州第一の緒面に、びくともせぬは我折れ申す。──さて、更めて内方へ、ものも、案内を頼みましょう。

女童三　屋根から入った小父さんはえ？

朱の盤　これはまた御挨拶だ。唯、猪苗代から参ったと、ささ、取次、取次。

女童一　知らん。

女童三　べいい。（赤べろする。）

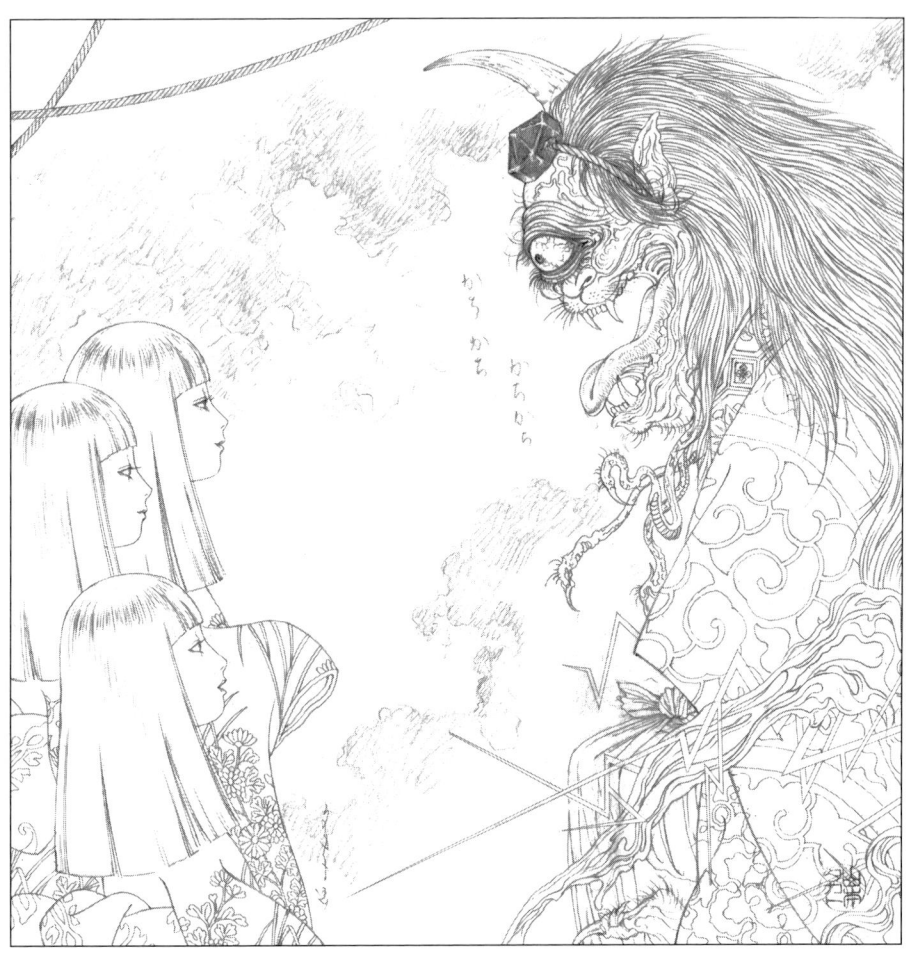

朱の盤　これは、いかな事――（立直る。大音に）ものも案内。

薄　　　どうれ。（壁より出迎う）いずれから。

朱の盤　これは、岩代国会津郡十文字ヶ原青五輪のあたりに罷在る、奥州変化の先達、允殿館のあるじ朱の盤坊でござる。即ち猪苗代の城、亀姫君の御供をいたし罷出ました。当お天守富姫様へ御取次を願いたい。

薄　　　お供御苦労に存じ上げます。あなた、お姫様は。

朱の盤　（真仰向けに承塵を仰ぐ）屋の棟に、すでに輿をばお控えなさる。

薄　　　夫人も、お待兼ねでございます。

　　　　手を敲く。音につれて、侍女三人出ず。斉しく手をつく。

　　　　早や、御入らせ下さりませ。

朱の盤　（空へいう）輿傍へ申す。こなたにもお待うけじゃ。――姫君、これへお入りのよう、舌長姥を、取次がっせえ。

　　　　階子の上より、真先に、切禿の女童、うつくしき手鞠を両袖に捧げて出ず。また女童、襠襦、扇子を手にす。また女童、うしろに守刀を捧ぐ。あと圧えに舌長姥、亀姫、振袖、襠襦、文金の高髷、扇子を手にす。古びて黄ばめる練衣、褪せたる紅の袴にて従い来る。

　　　　天守夫人、侍女を従え出で、設けの座に着く。

薄　　（そと亀姫を仰ぐ）お姫様。

出むかえたる侍女ら、皆ひれ伏す。

亀姫　　お許し。

しとやかに通り座につく。唯、夫人と面を合すとともに、双方よりひたと褥の膝を寄す。

夫人　　（親しげに微笑む）お亀様。
亀姫　　お姉様、おなつかしい。
夫人　　私もお可懐い。——

——（間。）

女郎花　　夫人さま。（と長煙管にて煙草を捧ぐ。）
夫人　　（取って吸う、そのまま吸口を姫に渡す）この頃は、めしあがるそうだね。
亀姫　　ええ、どちらも。（うけて、その煙草を吸いつつ、左の手にて杯の真似をす。）
夫人　　困りましたねえ。（また打笑む。）
亀姫　　ほほほ、貴女を旦那様にはいたすまいし。
夫人　　憎らしい口だ。よく、それで、猪苗代から、この姫路まで——道中五百里はあろうねえ、
　　　　……お年寄。
舌長姥　　御意にございます。……海も山もさしわたしに、風でお運び遊ばすゆえに、半日路には

夫人　足りませぬが、宿々を歩いましたら、五百里……されば五百三十里、もそっともござりましょうぞ。

亀姫　ああね。（亀姫に）よく、それで、手鞠をつきに、わざわざ此処までおいでだね。

夫人　否、お憎らしい。

亀姫　でございますから、お姉様は、私がお可愛うございましょう。

夫人　御勝手。（扇子を落す。）

亀姫　やっぱりお可愛い。（その背を抱き、見返して、姫に附添える女童に）どれ、お見せ。（手鞠を取る）まあ、綺麗な、私にも持って来て下されば可いものを。

朱の盤　ははッ。（その白布の包を出し）姫君より、貴女様へ、お心入れの土産がこれに。申すは、差出がましゅうござるなれど、これは格別、奥方様の思召しにかないましょう。…何と、姫君。（色を伺う。）

夫人　ああ、お開き。

亀姫　それはそれは、お嬉しい。が、お亀様は人が悪い、中は磐梯山の峰の煙か、虚空蔵の人魂ではないかい。

夫人　似たもの。ほほほほ。

亀姫　要りません、そんなもの。

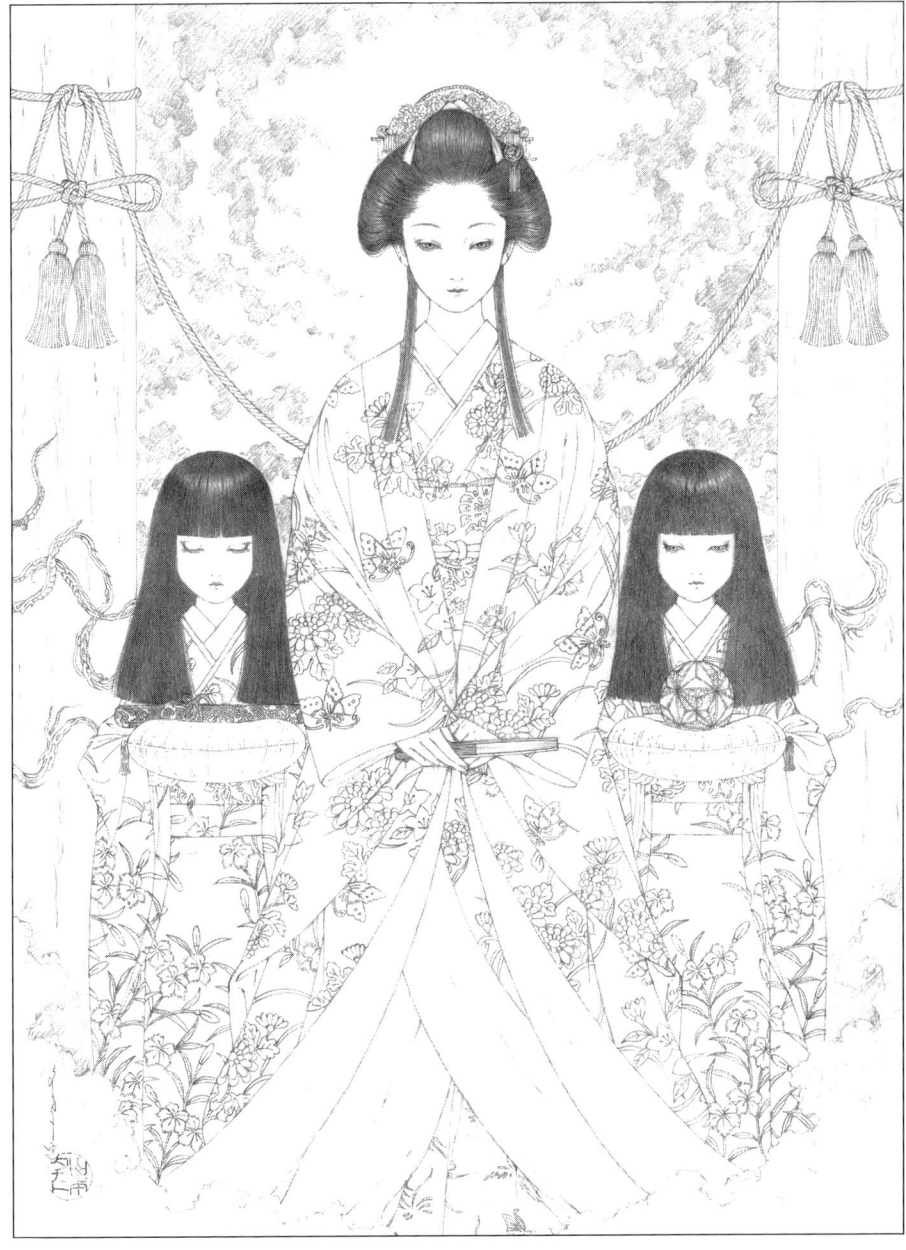

亀姫　　上げませぬ。

朱の盤　いや先ず、（手を挙げて制す）おなかがよくてお争い、お言葉の花が蝶のように飛びまして、お美しい事でござる。……さて、こなたより申す儀ではなけれども、奥方様、この品ばかりはお可厭ではござるまい。包を開く、首桶。中より、色白き男の生首を出し、もどどりを摑んで、ずうんと据う。や、不重宝、途中揺溢いて、これは汁が出ました。（その首、血だらけ）これ、姥殿、姥殿。

舌長姥　あいあい、あいあい。

朱の盤　御進物が汚れたわ。鱗の落ちた鱸の鰭を真水で洗う、手の悪い魚売人には似たれども、その儀では決してない。姥殿、こなた、一拭い、清めた上で進ぜまいかの。

夫人　　（煙管を手に支き、面正しく屹と視て）気違いには及びません、血だらけなは、なおおいしかろう。

舌長姥　こぼれた羹は、埃溜の汁でござるわの、お塩梅には寄りませぬ。汚穢や、見た目に、汚穢や。どれどれ掃除して参らしょうぞ。（紅の袴にて膝行り出で、桶を籔手に犇と圧え、白髪を、ざっと捌き、染めたる歯を角に開け、三尺ばかりの長き舌にて生首の顔の血をなめる）汚穢や、汚穢やの。（ぺろぺろ）汚穢やの、汚穢やの、ああ、甘味やの、汚穢やの、ああ、汚穢いぞの、やれ、甘味いぞのう。

朱の盤　（慌しく遮る）やあ、姥さん、歯を当てまい、御馳走が減りはせぬか。

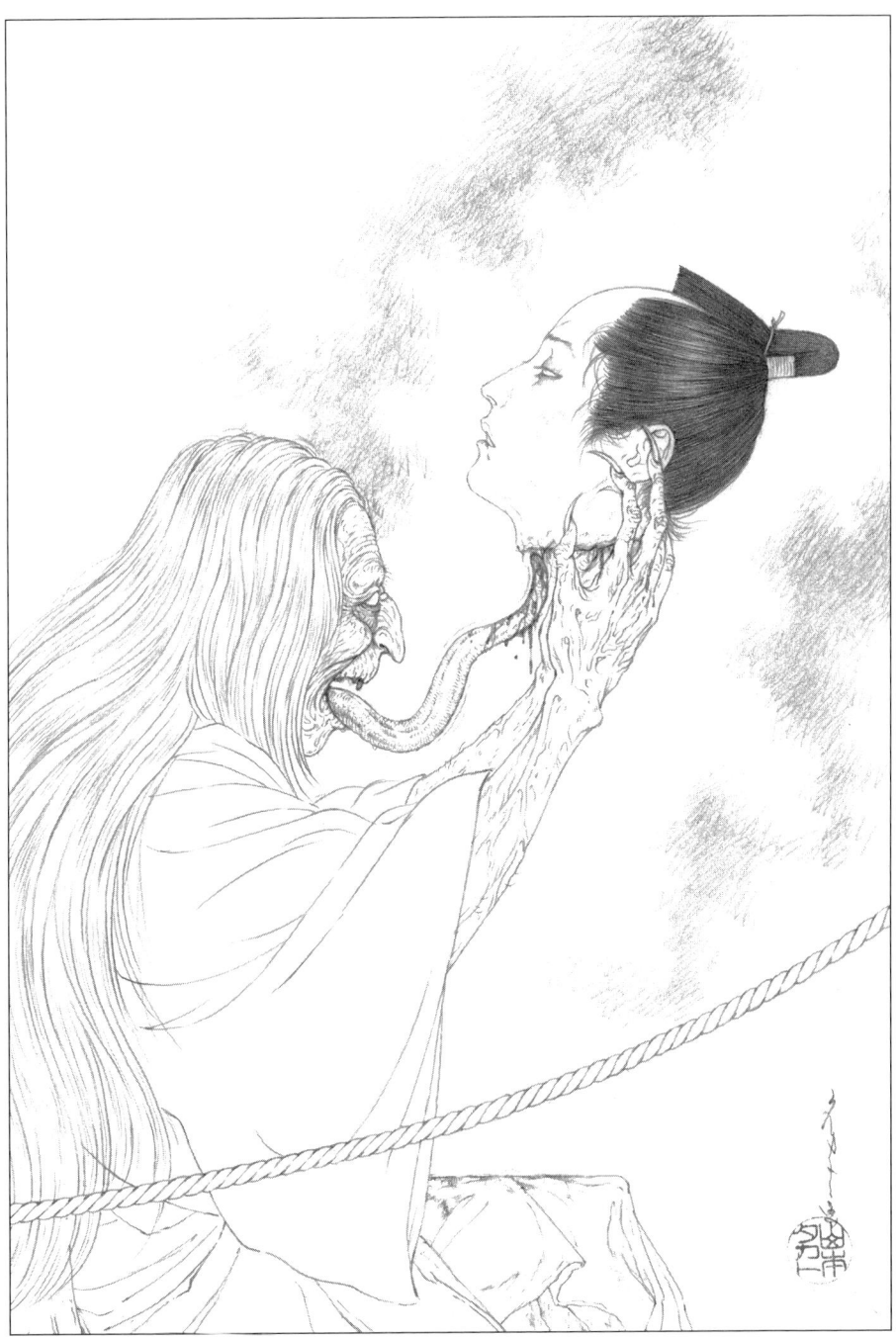

舌長姥　何のいの。(ぐったりと衣紋を抜く)取る年の可恐しさ、近頃は歯が悪うて、人間の首や、沢庵の尻尾はの、かくやにせねば咽喉へは通らぬ。そのままの形では、金花糖の鯛でさえ、横嚙りにはならぬ事よ。

朱の盤　後生らしい事を言うまい、彼岸は過ぎたぞ。――いや、奥方様、この姥が件の舌にて舐めますると、鳥獣も人間も、とろとろと消えて骨ばかりになりますわ。……そりゃこそ、申さぬことではなかった。お土産の顔つきが、時の間に、細長うなりました。なれども、過失の功名、死んで変りました人相が、かえって、もとの面体に戻りました。……姫君も御覧ぜい。

亀姫　(扇子を顔に、透かし見る)ああ、ほんになあ。

薄　侍女ら一同、瞬きもせず熟と視る。誰も一口食べたそう。

御前様――あの、皆さんも御覧なさいまし、亀姫様お持たせのこの首は、もし、この姫路の城の殿様の顔に、よく似ているではござんせぬか。

桔梗　真に、瓜二つでございますねえ。

夫人　(打頷く)お亀様、このお土産は、これは、たしか……

亀姫　はい、私が廂を貸す、猪苗代亀ヶ城の主、武田衛門之介の首でございますよ。

夫人　まあ、貴女。(間)私のために、そんな事を。

亀姫　構いません、それに、私がいたしたとは、誰も知りはしませんもの。私が城を出ます時はね、まだこの衛門之介はお妾の膝に凭掛って、酒を飲んでおりました。お大名のくせに意地が汚くってね、鯉汁を一口に食べますとね、魚の腸に針があって、それが、咽喉へさゝって、それで亡くなるのでございますから、今頃丁どそのお膳が出たぐらいでございますよ。（ふと驚く。扇子を落す）まあ、うっかりして、この咽喉に針がある。（もとどりを取って上ぐ）大変なことをした、お姉様に刺さったらどうしよう。

夫人　しばらく！　折角、あなたのお土産を、いま、それをお抜きだて、衛門之介も針が抜けて、蘇返ってしまいましょう。

朱の盤　いかさまな。

夫人　私が気をつけます。可うございす。（扇子を添えて首を受取る）お前たち、瓜を二つは知れたこと、この人はね、この姫路の城の主、播磨守とは、血を分けた兄弟だよ。

　　　ちょっと、侍女ら目と目を見合わす。

　　　みずから、獅子にお供え申そう。獅子、その牙を開き、首を呑む。首、その口に隠る。

二九

亀姫　（熟と視る）お姉様、お美しい。

夫人　え。

亀姫　旦那様が、おいで遊ばす。

夫人　――夫人、姫と顔を合す、互に莞爾とす。

亀姫　何の不足はないけれど、……お互に……

夫人　嘘が真に。

亀姫　こんな男が欲しいねえ。――ああ、男といえば、お亀様、あなたに見せるものがある。――桔梗さん。

桔梗　はい。

夫人　あれを、ちょっと。

桔梗　畏まりました。（立つ）

朱の盤　（不意に）や、姥殿、獅子のお頭に見惚れまい。尾籠千万。

舌長姥　（時に、うしろ向きに乗出して、獅子頭を視めつつあり）老人じゃ、当館奥方様も御許され。

朱の盤　見惚れるに無理はないわいの。

いやさ、見惚れるに仔細はないが、姥殿、姥殿は其処にいて舌が届く。（苦笑す。）

舌長姥思わず正面にその口を蔽う。侍女ら忍びやかに皆笑う。

桔梗、鍬形打ったる五枚錣、金の竜

頭の兜を捧げて出ず。夫人と亀姫の前に置く。

夫人　貴女、この兜はね、この城の、播磨守が、先祖代々の家の宝で、十七の奥蔵に、五枚鍛えに九ツの錠を下して、大切に秘蔵をしておりますのをね、今日お見えの嬉しさに、実は、貴女に上げましょうと思って取出して置きました。けれども、唯思っただけの、申訳に、お目に掛け産で、私のはお恥しくなりました。それだから、御心入の貴女のお土ますばかり。

亀姫　否、結構、まあ、お目覚しい。

夫人　差上げません。第一、あとで気がつきますとね、久しく蔵込んであって、かび臭い。蘭麝の薫も何にもしません。大阪城の落ちた時の、木村長門守の思切ったようなのだと可いけれど、……勝戦のうしろの方で、矢玉の雨宿をしていた、ぬくいのらしい。御覧なさい。（鉢金の輝く裏を返す）ほんに、葛や、討死をした兜ではありませんね。

亀姫　だから、およしなさいまし、葛や、しばらく其処へ。

夫人　お帰りまでに、屹とお気に入るものを調えて上げますよ。指図のまま、葛、その兜を獅子頭の傍に置く。

亀姫　それよりか、お姉様、早く、あのお約束の手鞠を調えて上げます。

夫人　ああ、遊びましょう。──彼方へ。──城の主人の鷹狩が、雨風に追われ追われて、

三一

もうやがて大手さきに帰る時分、貴女は沢山お声がいいから、この天守から美しい声が響くと、また立騒いでお煩い。

朱の盤　亀姫のかしずきたち、皆立ちかかる。

　いや、御先達、お山伏は、女たちと此処で一献お汲みがよいよ。

亀姫　吉祥天女、御功徳でござる。

夫人　ああ、姥、お前も大事ない、ここにいてお相伴をしや。——お姉様に、私から我儘をしますから。（肱を張って叩頭す。）

舌長姥　尤さ。

朱の盤　もし、通草、山ぐみ、山葡萄、手造りの猿の酒、山蜂の蜜、蟻の甘露、諸白もござる。が、お二人様のお手鞠は、唄を聞きますばかりでも寿命の薬と承る。かように年を取りますと、慾も、得も、はは、覚えませぬ。唯もう、長生がしとうございましてのう。

舌長姥　や、姥殿、その上のまた慾があるかい。

朱の盤　憎まれ山伏、これ、帰り途に舐められさっしゃるな。（とぺろりと舌。）

舌長姥　（頭を抱う）わあ、助けてくれ、角が縮まる。

　侍女たち笑う。

夫人　さ、お供をいたしましょうの。

　夫人を先に、亀姫、薄と女の童ら、皆行く。五人の侍女と朱の盤あり。

桔梗　お先達、さあさあ、お寛ぎなさいまし。

朱の盤　寛がいで何とする。やあ、えいとな。

萩　もし、面白いお話を聞かして下さいましな。

朱の盤　聞かさいで何とする。（扇を笏に）それ、山伏と言っぱ山伏なり。兜巾と言っぱ兜巾なり。某が、このいら高の数珠に掛け、いで一祈り祈るならば、などか利験のなかるべき。橋の下の菖蒲は、誰が植えた菖蒲ぞ、ぼろぼん、ぼろぼん、ぼろぼんのぼろぼん。侍女らわざとはらはらと逃ぐ、朱の盤五人を追廻す。ぼろぼんぼろぼん、ぼろぼんぼろぼん。（やがて侍女に突かれて撞と倒る）恋路と言っぱ闇夜なり。野道山路厭いなく、修行積んだる某が、このいら高の数珠に掛け、いで一祈り祈るならば、などか利験のなか

葛　利験はござんしょうけれどな、そんな話は面白うござんせぬ。

朱の盤　（首を振って）ぼろぼん、ぼろぼん。

　　　鞠唄聞ゆ。

　──私が姉さん三人ござる、一人姉さん鼓が上手、
　一人姉さん太鼓が上手、
　いっちょいのが下谷にござる。

葛　　下谷一番達しゃでござる。二両で帯買うて、三両で括けて、括けめ括けめに七総さげて、折りめ折りめに、いろはと書いて。——

朱の盤　さあ、お先達、よしの葉の、よい女郎衆ではござんせぬが、参ってお酌。（扇を開く。）丁どあるある。いで、お肴を所望しよう。……などか利験のなかるべき。

桔梗　その利験ならごさんしょう。女郎花さん、撫子さん、ちょっと、お立ちなさいまし。両女立つ。

ぼろぼんぼろぼん。（同じく扇子にうく）おとととと、

　　　ここを何処ぞと、もし人問わば、ここは駿河の府中の宿よ、人に情を掛川の宿よ。雉子の雌鳥ほろりと落ちて、打ちきせて、しめて、しょのしょのいとしょの、そぞろいとしゅうて、遣瀬なや。

朱の盤　やんややんや。

葛　　今度はお先達、さあ。

女郎花　貴方がお立ちなさいまし。

朱の盤　ぼろぼん、ぼろぼん。こなた衆思ざしを受きょうならば。

侍女五人扇子を開く、朱の盤杯を一順す。即ち立つ。腰なる太刀をすらりと抜き、以前の兜を切先にかけて、衝と天井に翳し、高慢に拍子を踏んで――
戈鋋剣戟を降らすこと電光の如くなり。
盤石巌を飛ばすこと春の雨に相同じ。
然りとはいえども、天帝の身には近づかで、
修羅かれがためにに破らる。

――お立ち――、（陰より諸声。）

亀姫　手早く太刀を納め、兜をもとに直す、一同ついいる。
　　　お姉様、今度は貴方が、私へ。

夫人　はい。

亀姫　お早々と。

舌長姥　お早々と。

夫人　（頷きつつ、連れて廻廊にかかる。目の下遙に瞰下す）ああ、鷹狩が帰って来た。

亀姫　（ともに、瞰下す）先刻私が参る時は、蟻のような行列が、その鉄砲で、松並木を走っていました。ああ、首に似た殿様が、馬に乗って反返って、威張って、本丸へ入って来ますね。播磨守さ。

夫人　まあ、翼の、白い羽の雪のような、いい鷹を持っているよ。

夫人　おお。(軽く胸を打つ) 貴女。(間) あの鷹を取って上げましょうね。

亀姫　まあ、どうしてあれを。

夫人　見ておいで、それは姫路の、富だもの。蓑を取って肩に装う。美しき胡蝶の群、ひとしく装に舞う。颯と翼を開く風情す。

それ、人間の目には、羽衣を被た鶴に見える。

ひらりと落す時、一羽の白鷹颯と飛んで天守に上るを、手に捕う。

――わっという声、地より響く――

亀姫　お涼しい、お姉様。

夫人　この鷹ならば、鞠を投げてもとりましょう。――沢山お遊びなさいまし。

亀姫　あい。(嬉しげに袖に抱く。そのまま、真先に階子を上る。二、三段、唯振返りて、衝と鷹を雪の手に据うるや否や) 虫が来た。

夫人　(斉しくともに) む。(と肩をかわし、身を捻って背向になる、舞台に面を返す時、口に一条の征矢、いうとともに、袖を払って一筋の征矢をカラリと落す。矢は鷹狩の中より射掛けたる也。手にまた一条の矢を取る。下より射たるを受けたるなり) 推参な。

――忽ち、鉄砲の音、あまたたび――

薄　それ、皆さん。

侍女ら、身を垣にす。

朱の盤　姥殿、確り。（姫を庇うて大手を開く。）

亀姫　大事ない、大事ない。

夫人　（打笑む）ほほほ、皆が花火線香をお焚き——そうすると、鉄砲の火で、この天守が燃えると思って、吃驚して打たなくなるから。

——舞台やや暗し。鉄砲の音止む——

夫人、亀姫と声を合せて笑う、ほほほほ。

それ、御覧、次手にその火で、焼けそうな処を二三処焚くが可い、お亀様の路の松明にしょうから。

舞台暗し。

亀姫　お心づくしお嬉しや。然らば。

夫人　さらばや。

寂寞、やがて燈火の影に、うつくしき夫人の姿。舞台に唯一人のみ見ゆ。夫人うしろむきにて、獅子頭に対し、机に向い巻ものを読みつつあり。間を置き、女郎花、清らかなる小搔巻を持ち出で、静に夫人の背に置き、手をつかえて、のち去る。——

此処は何処の細道じゃ、細道じゃ。
天神様の細道じゃ、細道じゃ。

舞台一方の片隅に、下の四重に通ずべき階子の口あり。その口より、先ず一の雪洞顕れ、一廻りあたりを照す。やがて衝と翳すとともに、美丈夫、秀でたる眉に勇壮の気満つ。黒羽二重の紋着、萌黄の袴、臘鞘の大小にて、姫川図書之助登場。唄をききつつ低徊し、天井を仰ぎ、廻廊を窺い、やがて燈の影を視て、やや驚く。次で几帳を認む。彼が入るべき方に几帳を立つ。図書は躊躇の後決然として進む。瞳を定めて、夫人の姿を認む。剣夾に手を掛け、気構えたるが、じりじりと退る。

夫人　（間）誰。

図書　はっ。（と思わず膝を支く）某。

夫人　（面のみ振向く、――無言。）

図書　私は、当城の大守に仕うる、武士の一人でございます。

夫人　何しに見えた。

図書　百年以来、二重三重までは格別、当お天守五重までは、生あるものの参った例はありま

夫人　それだけの事か。

図書　かつまた、大殿様、御秘蔵の、日本一の鷹がそれまして、お天守のこのあたりへ隠れました。行方を求めよとの御意でございます。

夫人　翼あるものは、人間ほど不自由ではない。千里、五百里、勝手な処へ飛ぶ、とお言いなさるが可い。──用はそれだけか。

夫人　別に余の儀は承りませぬ。

夫人　五重に参って、見届けた上、如何計らえとも言われなかったか。

図書　いや、承りませぬ。

夫人　そして、お前も、こう見届けた上に、どうしようとも思いませぬか。

図書　お天守は、殿様のものでございます。如何なる事がありましょうとも、私一存にて、何と計らおうとも決して存じませぬ。

夫人　お待ち。この天守は私のものだよ。

図書　それは、貴方のものかも知れませぬ。また殿様は殿様で、御自分のものだと御意遊ばすかも知れませぬ。しかし、いずれにいたせ、私のものでないことは確でございます。自分のものでないものを、殿様の仰せも待たずに、どうしようとも思いませぬ。

夫人　すずしい言葉だね、その心なれば、此処を無事で帰してあげます。私も無事に帰られよう。

図書　冥加に存じます。

夫人　今度は、播磨が申しきけても、決して来てはなりません。此処は人間の来る処ではないのだから。——また誰も参らぬように。

図書　いや、私が参らぬ以上は、五十万石の御家中、誰一人参りますものはございますまい。皆生命が大切でございますから。

夫人　お前は、そして、生命は欲うなかったのか。

図書　私は、仔細あって、殿様の御不興を受け、お目通を遠ざけられ閉門の処、仰せつけの処を、急に御模様がえになったのでございます。上りますものがないために、急にお呼出しでございました。その御上使は、実は私に切腹仰せつけの御上使でございます。

夫人　では、この役目が済めば、切腹は許されますか。

図書　そのお約束でございました。

夫人　人の生死は構いませんが、切腹はさしたくない。私は武士の切腹は嫌いだから。しかし、思い掛なく、お前の生命を助けました。……悪い事ではない。今夜はいい夜だ。それではお帰り。

図書　姫君。

四五

図書　武士の面目に存じます――御免。

夫人　確にお言いなさいまし。留守でなければ、何時でもいるから。

図書　は、恐入ったる次第ではございますが、御姿を見ました事を、主人に申まして差支えはございませんか。

夫人　まだ、いますか。

雪洞を取って静かに退座す。夫人長煙管を取って、払く音に、図書板敷にて一度留まり、直ちに階子の口にて、燈を下に、壇に隠る。

鐘の音。

時に一休の大入道、面も法衣も真黒なるが、もの陰より甍を渡り梢を伝うが如くにして、舞台の片隅を伝い行き、花道なる切穴の口に踞まる。

鐘の音。

図書、その切穴より立顕る。

夫人すっと座を立ち、正面、鼓の緒の欄干に立ち熟と視る時、図書、雪洞を翳して高く天守を見返す、トタンに大入道さし覗き状に雪洞をふっと消す。図書身構す。大入道、大手を拡げてその前途を遮る。

鐘の音。

侍女ら、凜々しき扮装、揚幕より、懐剣、薙刀を構えて出づ。図書扇子を抜持ち、大入道を払い、懐剣に身を躱し、薙刀と丁と合わす。かくて一同を追込み、揚幕際に扇を揚げ、屹と天守を仰ぐ。

夫人、従容として座に返る。図書、手探りつつもとの切穴を捜る。（間）その切穴に没す。しばらくして舞台なる以前の階子の口より出づ。猶予わず夫人に近づき、手をつく。

（先んじて声を掛く。穏に）また見えたか。

夫人

図書　はっ、夜陰と申し、再度御左右を騒がせ、まことに恐入りました。

夫人　何しに来ました。

図書　御天守の三階中壇まで戻りますと、鳶ばかり大きさの、野衾かと存じます、大蝙蝠の黒い翼に、燈を煽ぎ消されまして、いかにとも、進退遽を失いましたにより、灯を頂きに参りました。

夫人　ただそれだけの事に。……二度とおいででないと申した、私の言葉を忘れましたか。

図書　針ばかり片割月の影もささず、下に向えば真の暗黒。男が、足を踏みはずし、壇を転がり落ちまして、不具になりましては、生効もないと存じます。上を見れば五重の此処より、幽にお燈がさしました。お咎めを以て生命をめさりょうとも、男といたし、階子から落ちて怪我をするよりはと存じ、御戒をも憚らず推参いたしてございます。

夫人　（莞爾と笑む）ああ、爽かなお心。そして、貴方はお勇しい。燈を点けて上げましょうね。

図書　いや、お手ずからは恐多い。私が。

夫人　否々、この燈は、明星、北斗星、竜の燈、玉の光もおなじこと、お前の手では、蠟燭には点きません。

図書　ははッ。（瞳を凝す。）

（座を寄す。）

夫人、世話めかしく、雪洞の蠟を抜き、短檠の灯を移す。燭をとって、熟と図書の面を視る、恍惚とす。

四九

夫人　（蠟燭を手にしたるまま）帰したくなくなった、もう帰すまいと私は思う。

図書　ええ。

夫人　貴方は、播磨が貴方に、切腹を申しつけたと言いました。それは何の罪でございます。

図書　私が拳に据えました、殿様が日本一とて御秘蔵の、白い鷹を、このお天守へ逸しました、その越度、その罪過でございます。

夫人　何、鷹をそらした、その越度、その罪過、ああ人間というものは不思議な咎を被せるものだね。その鷹は貴方が勝手に鳥に合せたのではありますまい。天守の棟に、世にも美しい鳥を視て、それが欲しさに、播磨守が、自分で貴方にいいつけて、勝手で自分でそらしたものを、貴方の罪にしますのかい。

図書　主と家来でございます。仰せのまま生命をさし出しますのが臣たる道でございます。

夫人　その道は曲っていましょう。間違ったいいつけに従うのは、主人に間違った道を踏ませるのではありませんか。

図書　けれども、鷹がそれました。

夫人　ああ、主従とかは可恐しい。鷹とあの人間の生命とを取かえるのでございますか。よしそれも、貴方が、貴方の過失なら、君と臣というものそれが道なら仕方がない。けれども、播磨がさしずなら、それは播磨の過失というもの。第一、鷹を失ったのは、貴方ではあり

図書　ません。あれは私が取りました。

夫人　やあ、貴方が。

図書　まことに。

夫人　ええ、お怨み申上ぐる。（刀に手を掛く。）

図書　鷹は第一、誰のものだと思います。鷹には鷹の世界がある。露霜の清い林、朝嵐夕風の爽かな空があります。決して人間の持ちものではありません。諸侯なんどというものが、思上った行過ぎな、あの、鷹を、唯一人じめに自分のものと、つけ上りがしています。貴方はそうは思いませんか。

夫人　（沈思す、間）美しく、気高い、そして計り知られぬ威のある、姫君。――貴方にはお答出来かねます。

図書　否、否、かどだてて言籠めるのではありません。私の申すことが、少しなりともお分りになりましたら、あのその筋道の分らない二三の丸、本丸、太閤丸、廓内、御家中の世間へなど、もうお帰りなさいますな。白銀、黄金、球、珊瑚、千石万石の知行より、私が身を捧げます。腹を切らせる殿様のかわりに、私の心を差上げましょう。貴方お帰りなさいますな。

図書　迷いました، 姫君。殿に金鉄の我が心も、波打つばかり悩乱をいたします。が、決心が

五一

夫人　出来ません。私は親にも聞きたし、師にも教えられたし、書もつにも聞かねばなりません。お暇を申上げます。

図書　（歎息す）ああ、まだ貴方は、世の中に未練がある。それではお帰りなさいまし。（この時蠟燭を雪洞に）

夫人　はい。

図書　途方に暮れつつ参ります。迷の多い人間を、あわれとばかり思召せ。

夫人　ああ、優しいそのお言葉で、なおお帰りしたくなくなった。（袂を取る。）

図書　屹として袖を払う）強いて、断って、お帰しなくば、お抵抗をいたします。

夫人　（微笑み）あの私に。

図書　おんでもない事。

夫人　まあ、お勇ましい、凜々しい。あの、獅子に似た若いお方、お名が聞きたい。

図書　夢のような仰せなれば、名のありなしも覚えませぬが、姫川図書之助と申します。

夫人　可懐い、嬉しいお名、忘れません。

図書　以後、お天守下の住かいには、誓って礼拝をいたします。——御免。（御と立つ）

夫人　ああ、図書様、しばらく。

図書　是非もない、所詮活けてはお帰しない掟なのでございますか。

夫人　ほほほ、播磨守の家中とは違います。ここは私の心一つ、掟なぞは何にもない。

図書　それを、お呼留め遊ばしたは。

夫人　おはなむけがあるのでござんす。——人間は疑深い。卑怯な、臆病な、我儘な、殿様などはなおの事。貴方がこの五重へ上って、この私を認めたことを誰も真個にはせぬであろう。清い、爽かな貴方のために、記念の品をあげましょう。（静に以前の兜を取る）——これを、その記念にお持ちなさいまし。

図書　——貴方、見覚えがありますか。

夫人　金銀は堆けれど、そんなにいい細工ではありません。しかし、武田には大切な道具。

図書　存じも寄らぬ御たまもの、姫君に向い、御辞退はかえって失礼。余り尊い、天晴な御兜。

夫人　（疑の目を凝しつつあり）まさかとは存ずるなり、私とても年に一度、虫干の外には拝しませぬが、ようも似ましたお家の重宝、青竜の御兜。

図書　まったく、それに違いありません。

夫人　（愕然とす。急に）これにこそ足の爪立つばかり、心急ぎがいたします、御暇を申うけます。

図書　今度来ると帰しません。

夫人　誓って、——仰せまでもありません。

図書　然らば。

夫人　はっ。（兜を捧げ、やや急いで階子に隠る。）

夫人　（ひとりもの思い、机に頰杖つき、獅子にもの言う）貴方、あの方を——私に下さいまし。

薄　（静かに出ず）御前様。

夫人　薄か。

薄　立派な方でございます。

夫人　今まで、あの人を知らなかった、目の及ばなかった私は恥かしいよ。

薄　予てのお望みに叶うた方を、何でお帰しなさいました。

夫人　生命が欲しい。抵抗をするというもの。

薄　御一所に、此処にお置き遊ばすまで、何の、生命を取り遊ばすのではないのだと思います。

夫人　あの人たちの目から見ると、此処に居るのは活きたものではないのでございますのに。

薄　それでは、貴方の御容色と、そのお力で、無理にもお引留めが可うございますのに。何の、抵抗をしました処で。

夫人　否、容色はこちらからは見せたくない。力で、人を強いるのは、播磨守なんぞの事、真の恋は、心と心、……（軽く）薄や。

薄　は。

夫人　しかし、そうはいうものの、白鷹を据えた、鷹匠だと申すよ。——縁だねえ。

薄　屹と御縁がございますよ。

夫人　私もどうやら、そう思うよ。

薄　　奥様、いくら貴女のお言葉でも、これは些と痛入りました。

夫人　私も痛入りました。

薄　　これはまた御挨拶でございます——あれ、何やら、御天守下が騒がしい。（立って欄干に出で、遙かに下を覗込む）……まあ、御覧なさいまし。

夫人　（座のまま）何だえ。

薄　　武士が大勢で、篝を焚いております。ああ、武田播磨守殿、御出張、床几に掛ってお控えだ。おぬるくて、のろいくせに、もの見高な、せっかちで、お天守見届けのお使いの帰るのを待兼ねて、推出したのでございます。もしもしえ、図書様のお姿が小さく見えます。奥様、おたまじゃくしの真中で、御紋着の御紋も河骨、すっきり花が咲いたような、水際立ってお美しい。……奥様。

夫人　知らないよ。

薄　　おお、兜あらためがはじまりました。おや、吃驚した。あの、殿様の漆見たいな太い眉毛が、びくびくと動きますこと。先刻の亀姫様のお土産の、兄弟の、あの首を見せたら、どうでございましょう。ああ、御家老がいます。あの親仁も大分百姓を痛めて溜込みましたね。そのかわり頭が禿げた。まあ、皆が図書様を取巻いて、お手柄にあやかるのか知ら。おや、

夫人　追取刀だ。何、何、何、まあ、奥様奥様。
　　　もう可い。

薄　　ええ、もう可いではございません。図書様を賊だ、と言います。御秘蔵の兜を盗んだ謀叛人、謀叛人、殿様のお首に手を掛けたも同然な逆賊でございますとさ。お庇で兜が戻ったのに。——何てまあ、人間というものは。——あれ、捕手が掛った。忠義と知行で、てむかいはなさらぬかしら。しめた、投げた、嬉しい。其処だ。御家老が肩衣を撥ねましたよ。あら、可哀相に、首が飛びます。大勢が抜連れた。あれ危い。豪い。図書様抜合せた。……一人腕が落ちた。あら、胴切。また何も働かずとも可いことを、五両二人扶持合せた、あら、可哀相に、首が飛びます。秀吉時分から、見馴れていながら、何だねえ、騒々しい。

夫人　（片膝立つ）可し、お手伝い申せ。

薄　　騒がずにはいられません。多勢に一人、あら切抜けた、図書様がお天守に遁込みました。追掛けますよ。槍まで持出した。——（欄干をするすると）図書様が、二重へ駈上っておいでなさいます。大勢が追詰めて。

夫人　（片膝立つ）可し、お手伝い申せ。お腰元衆、お腰元衆。——（呼びつつ忙しく階子を下り行く。）

　　　夫人、片手を掛けつつ几帳越に階子の方を瞰下す。

──や、や、や、──激しき人声、もの音、足蹈。──図書、もどりを放ち、衣服に血を浴ぶ。刀を振って階子の口に、一度屹と下を見込む。肩に波打ち、はっと息して撞となる。

夫人　図書様。

図書　（心づき、蹌踉と、かつ呼吸せいて急いで寄る）姫君、お言葉をも顧みず、三度の推参をお許し下さい。私を賊……賊……謀逆人、逆賊と申して。

夫人　よく存じておりますよ。昨日今日、今までも、お互に友と呼んだ人たちが、いかに殿の仰せとて、手の裏を反すように、ようまあ、あなたに刃を向けます。

図書　はい、微塵も知らない罪のために、人間同志に殺されましては、おなじ人間、断念められない。貴女のお手に掛ります。——御禁制を破りました、御約束を背きました、その罪に伏します。速に生命をお取り下されたい。

夫人　ええ、武士たちの夥間ならば、貴方のお生命を取りましょう。私と一所には、いつまでもお活きなさいまし。

図書　（急きつつ）お情余る、お言葉ながら、活きようとて、討手の奴儕、決して活かして置きません。早くお手に掛けて下さいまし。貴女に生命を取らるれば、もうこの上のない本望、彼らに討たるるのは口惜しい。（夫人の膝に手を掛く）さ、生命を、生命を——こういう中にも取詰めて参ります。

夫人　否、此処までは来ますまい。

図書　五重の、その壇、その階子を、鼠の如く、上りつ下りついたしおる。……予ての風説、

夫人　鬼神（おにがみ）より、魔（ま）よりも、此処（ここ）を恐（おそ）しと存じておるゆえ、聊（いささ）か躊躇（ちゅうちょ）はいたしますが、既に、私の、かく参（まい）ったを、認（みと）めております。こういう中（うち）にも、唯今（たったいま）。

ああ、それもそう、何より前（さき）に、貴方（あなた）をおかくまい申して置こう。（獅子頭（ししがしら）を取る、母衣（ほろ）を開いて、図書の上に蔽（かくま）いながら）この中へ……この中へ──

図書　や、金城鉄壁（きんじょうてっぺき）。

夫人　否（いいえ）、柔（やわ）らか。

図書　仰（おお）せの通り、真綿（まわた）よりも。

夫人　そして、確（しか）かり、私におつかまりなさいまし。

図書　失礼御免（しつれいごめん）。

夫人の背よりその袖に縋（すが）る。縋（すが）る、と見えて、身体（からだ）その母衣（ほろ）の裾（すそ）なる方にかくる。獅子頭（ししがしら）を捧げつつ、夫人の面（おもて）、なお母衣の外に見ゆ。

討手（うって）どやどやと入込（いりこ）み、唯見（ただみ）てわっと一度退（しりぞ）く時、夫人も母衣に隠る。唯（ただ）一頭青面（せいめん）の獅子（しし）猛然として舞台にあり。

九平　討手（うって）。小田原修理（おだわらしゅり）、山隅九平（やまずみくへい）、その他。抜身（ぬきみ）の槍、刀。中には仰山（ぎょうさん）に小具足（こぐそく）をつけたるもあり。大勢。

修理　（雪洞（ぼんぼり）を寄（よ）す）やあ、怪（あや）しく、凄（すご）く、美しい、婦（おんな）の立姿（たちすがた）とは、これだ。化（ば）けるわ化るわ。御城（おしろ）の瑞兆（ずいちょう）、天人（てんにん）の如（ごと）き鶴を御覧あって、殿様、鷹を合せたまえば、

九平　鷹はそれを破袋を投落す、……言語道断。

修理　他にない、姫川図書め、死ものぐるいに、確にそれなる獅子母衣に潜ったに相違なし。

九平　やあ、上意だ、逆賊出合え。山隈九平向うたり。

修理　待て、山隈、先方で潜った奴だ。呼んだって出やしない。取って押え、引摺出せ。

九平　それ、面々。

気をつけい、うかつにかかると怪我をいたす。元来この青獅子が、並大抵のものではないのだ。伝え聞く、以前これは御城下はずれ、群鷲山の地主神の宮に飾ってあった。二代以前の当城殿様、お鷹狩の馬上から――一人町里には思いも寄らぬ、都方と見えて、世にも艶麗な女の、行列を颯と避けて、その宮へかくれたのを――とろんこの目で御覧じたわ。こなたは鷹狩、もみじ山だが、いずれ戦に負けた国の、上﨟、貴女、貴夫人たちの落人だろう。絶世の美女だ。しゃっ攫出いて奉れ、とある。

御近習、宮の中へ闖入し、人妻なればと、いなむを捕えて、手取足取しようとしたれば、舌を嚙んで真俯向けに倒れて死んだ。その時にな、この獅子頭を熱と視て、あれ獅子や、名誉の作かな。わらわにかばかりの力あらば、虎狼の手にかかりはせじ、と吐いた、とな。続いて三年、毎年、秋の大洪水よ。何が、死骸取片づけの山神主が見た、と申すには、獅子が頭を逆にして、その婦の血を舐め舐め、目から涙を流いたというが触出しでな。打続く洪水は、その婦の怨だと、国中の是沙汰だ。婦が前髪にさしたのが、死ぬ時、髪をこぼれ落ちたという櫛を拾って来て、近習が復命をした、白木に刻んだ三輪牡丹高彫のさし櫛をな、その時の馬上の殿様は、澄して袂へお入れなさった。おもしろい、水を出さば、祟を恐れぬ荒気の大名。生捉って来てな、此処へ打上げたその獅子頭だ。以来、奇異妖変さながら魔所のように沙汰する天守、まさかとは思うたが、目のあたり不思議を見るわ。──心してかかれ。
　天守の五重を浸して見よ、とそれ、

修理　討手、槍にて立ちかかる。獅子狂う。討手辟易す。修理、九平ら、抜連れ抜連れ一同立掛る。獅子狂う。また辟易す。

木彫にも精がある。活きた獣も同じ事だ。目を狙え、目を狙え。

九平、修理、力を合せて、一刀ずつ目を傷く、獅子伏す。討手その頭をおさう。

九平　心得た、槍をつけろ。

図書　（母衣を撥退け刀を揮って出ず。口々に罵る討手と、一刀合すと斉しく）ああ、目が見えない。

夫人　（押倒され、取って伏せらる）無念。

　　　（獅子の頭をあげつつ、すっくと立つ。黒髪乱れて面凄し。手に以前の生首の、もとどりを取って提ぐ）

誰の首だ、お前たち、目のあるものは、よっく見よ。（どっしと投ぐ。）

　　　――討手わッと退き、修理、恐る恐るこれを拾う。

修理　南無三宝。

九平　殿様の首だ。播磨守様御首だ。

修理　一大事とも言いようなし。御同役、お互に首はあるか。

九平　可恐い魔ものだ。うかうかして、こんな処にいべきでない。

　　　討手一同、立つ足もなく、生首をかこいつつ、乱れて退く。

図書　姫君、何処においでなさいます。姫君。

夫人、悄然として、立ちたるまま、もの言わず。

図書　（あわれに寂しく手探り）姫君、何処においでなさいます。私は目が見えなくなりました。

夫人　（忍び泣きに泣く）貴方、私も目が見えなくなりました。

図書　ええ。

夫人　侍女たち、侍女たち。——せめては燈を——

——皆、盲目になりました。誰も目が見えませんのでございます。——（口々に一同はっと泣く声、壁の彼方に聞ゆ。）

夫人　（獅子頭とともにハタと崩折る）獅子が両眼を傷つけられました。この精霊で活きましたものは、一人も見えなくなりました。図書様、……何処に。

図書　姫君、何処に。

さぐり寄りつつ、やがて手を触れ、はっと泣き、相抱く。

夫人　何と申そうようもない。貴方お覚悟をなさいまし。今持たせて遣った首も、天守を出れば消えましょう。討手は直ぐに引返して参ります。私一人は、雲に乗ります、風に飛びます、虹の橋も渡ります。討手には出来ません。ああ口惜しい。あれら討手のものの目に、蓑笠着ても天人の二人揃った姿を見せて、日の出、月の出、夕日影にも、おがませようと思ったのに、私の方が盲目になっては、ただお生命さえ助けられない。堪忍して下さいまし。

図書　くやみません！　姫君、あなたのお手に掛けて下さい。

夫人　ええ、人手には掛けますまい。そのかわり私も生きてはおりませぬ、お天守の塵、煤ともなれ、落葉になって朽ちましょう。

図書　やあ、何のために貴女が、美しい姫の、この世にながらえておわすを土産に、冥土へ行くのでございます。

夫人　否、私も本望でございます、貴方のお手にかかるのが。

図書　真実のお声か、姫君。

夫人　ええ何の。――そうおっしゃる、お顔が見たい、唯一目。……千歳百歳に唯一度、たった一度の恋だのに。

図書　ああ、私も、もう一目、あの、気高い、美しいお顔が見たい。（相縋る。）

夫人　前世も後世も要らないが、せめてこうしていとうございます。

図書　や、天守下で叫んでいる。

夫人　（屹となる）口惜しい、もう、せめて一時隙があれば、夜叉ヶ池のお雪様、遠い猪苗代の妹分に、手伝を頼もうものを。

図書　覚悟をしました。姫君、私を。……

夫人　私は貴方に未練がある。否、助けたい未練がある。

図書　猶予をすると討手の奴、人間なかまに屠られます、貴女が手に掛けて下さらずば、自分、我が手で。——（一刀を取直す。）

夫人　切腹はいけません。ああ、是非もない。それでは私が御介錯、舌を嚙切ってあげましょう。それと一所に、胆のたばねを——この私の胸を一思いに。

図書　せめてその、ものをおっしゃる、貴方の、ほのかな、口許だけも、見えたらばな。

夫人　貴方の睫毛一筋なりと。（声を立ててともに泣く。）

奥なる柱の中に、大音あり。

——待て、泣くな泣くな。——

桃六　美しい人たち泣くな。(つかつかと寄って獅子の頭を撫で)先ず、目をあけて進ぜよう。

火打袋より一挺の鑿を抜き、双の獅子の眼に当つ。

——夫人、図書とともに、あっという——

桃六　どうだ、の、それ、見えよう。ははははは、ちゃんと開いた。おお、もう笑うか。誰がよ誰がよ、あっはっはっ。

夫人　お爺様。

図書　御老人、あなたは。

桃六　されば、誰かの櫛に牡丹も刻めば、この獅子頭も彫った、近江之丞桃六という、丹波の国の楊枝削よ。

夫人　まあ、(図書と身を寄せたる姿を心づく) こんな姿を、恥かしい。図書も、ともに母衣を被ぎて姿を蔽う。

桃六　むむ、見える、恥しそうに見える、極りの悪そうに見える、がやっぱり嬉しそうに見える、はっはっはっはっ。睦じいな若いもの。(石を切って、ほくちをのぞませ、煙管を横銜えに煙草を、

すばすば）気苦労の挙句は休め、安らかに一寝入りさっせえ。そのうちに、もそっと、その上にも清い目にして進ぜよう。

鑿を試む。月影さす。

そりゃ光がさす、月の光あれ、眼玉。（鑿を試み、小耳を傾け、鬨の如く叫ぶ天守下の声を聞く）世は戦でも、胡蝶が舞う、撫子も桔梗も咲くぞ。……馬鹿めが。（呵々と笑う）ここに獅子がいる。お祭礼だと思って騒げ。（鑿を当てつつ）槍、刀、弓矢、鉄砲、城の奴ら。

―― 幕 ――

大正六年（一九一七）九月

解説

穴倉玉日

永遠(とわ)を生きる愛
── 「天守物語」百年によせて

　私は貴方(あなた)に未練がある。否(いいえ)、助けたい未練がある。

　いまや鏡花戯曲の最高傑作の名を不動のものとしている「天守物語」にあふれる、観る者聴く者の魂を揺さぶるような台詞の中で、最も印象的な一つを挙げるとしたら、私は無実の罪のために捕り手に追い詰められ、死を覚悟した若き鷹匠・姫川図書之助に対し、数百年来人間が足を踏み入れた例がないという異界──姫路城天守第五重を司る富姫が発した、このひと言を選ぶ。人間の生首を賞味するような妖怪たちを束ねる気高い妖姫でありながら、生身の青年を愛し、愛され、いっそその手で殺して欲しいとまで訴えられてなお、思い切れずにその生命(いのち)を守ろうとする彼女の姿に、おそらく鏡花が生涯あこがれ続けた真の女性的(フェミニティ)なるものを感じるからだ。
　約百年前の大正六年（一九一七）に発表された「天守物語」は、

"鏡花の自信作"と伝えられながらも生前に上演されることはなく、舞台作品として初めて日の目を見たのは鏡花没後の昭和二十六年（一九五一）であった。昭和四十三年十一月四日、鏡花生誕日に行われた三島由紀夫・澁澤龍彦の対談（『日本の文学４　尾崎紅葉・泉鏡花』収録　昭和四十三年　中央公論社）で再評価が促されて以降、最も上演回数の多い鏡花戯曲として舞台芸術はもちろん、少女漫画やイラストレーション、人形などの造形作品や伝統工芸に至るまで、ありとあらゆるアートシーンで新たな命を吹き込まれ続けている。

このように、おそらく鏡花本人も想像が及ばないほど多種多様な展開を見せた「天守物語」に、あえて挿画付きの美装本という、鏡花存命中から繰り返し行われてきた最もクラシカルな手法で挑んだのが本書である。

文学作品のビジュアル化には、活字を通して得た個々のイマジネーションに必ずしも適うとは限らないという、不可避のリスクがつきまとう。特に挿画は、他のアートに比して原作（活字）との距離のあまりの近さに、より諸刃の剣となりやすい。しかし、同時に絵師の研ぎ澄まされた感性と類い希なる創造性によって視覚

化されることで、羅列する文字の随所に埋め込まれた秘めたる魅力に気づかされ、息をのむような驚きと感動に身を震わせる思いができるのも確かだ。"平成耽美主義"を標榜した現代の浮世絵師ともいうべき山本タカト氏の挿画による「草迷宮」の衝撃から二年、今回はかの澁澤龍彥や寺山修司らとともに戦後の鏡花再評価の時代を生き、今なおグラフィックアートのファンタジスタとして斯界を牽引し続ける宇野亞喜良氏を新たに迎え、二氏の挿画と古典の薫りを漂わせた格調高いダン・ケニー氏の新訳による和英バイリンガル版で「天守物語」の世界を堪能するという、かつてない試みとなった。日本語を解する者の特権とも言うべき鏡花文学の美しさにこれまで触れ得なかった海外の人々は、宇野・山本両氏の挿画を通して、工芸品のごとく緻密で繊細な日本の伝統美と、世俗の論理を超え時空を恋にする不羈（ふき）の魂をあわせもつ作家として、泉鏡花の名を記憶するだろう。そして、百年を経てなお再生し続けるこの戯曲を通して、富姫の図書之助への想いに象徴される、愛する者を守り抜くがゆえの"強さ"を知り、鏡花が描いた女性美の根源にあるものを、自らの生の内に憶（おも）い起こすだろう。

穴倉玉日（あなくら たまき）
一九七三年福井県生まれ。金沢大学大学院博士課程（単位取得満期退学）を経て、二〇〇七年から泉鏡花記念館学芸員。泉鏡花研究会会員、日本近代文学会会員。共編著 別冊太陽『泉鏡花―美と幻想の魔術師』（平凡社）、泉鏡花研究会編『論集 泉鏡花 第五集』（和泉書院）、『絵本化鳥(けちょう)』（国書刊行会）

泉鏡花記念館
一九九九年十一月、鏡花が幼少時代を過ごした金沢市下新町の生家跡地に開館。原稿や書簡などの自筆資料のほか、鏑木清方、鰭崎英朋、小村雪岱らの装幀による鏡花本（初版本）の収蔵館としても知られ、鏡花の遺愛品などとともに作家と作品の紹介に努めている。
http://www.kanazawa-museum.jp/kyoka/

ダン・ケニー

一九三六年、アメリカ合衆国カンザス州生まれ。フィリップス大学にて音楽と哲学を専攻。同大学卒業後、一九五九年に来日。以後フリーランスの翻訳者として活動しつつ、上智大学と早稲田大学で日本の古典芸能や文化研究にいそしむ。英語による狂言の翻訳と実演、役者として様々のNHKドラマ出演のほか、『ジャパン・タイムズ』で日本の演劇についてコラムも担当していた。一九九七年には坂東玉三郎による『天守物語』を観劇している。また篠田正浩監督作品、坂東玉三郎主演の映画『夜叉ケ池』では英語字幕を担当した。
本書では、侍ことばや封建社会の時代風俗など、英訳の難しい『天守物語』独特のあやかしの世界を格調高く翻訳している。

宇野亞喜良（うの あきら）

一九三四年、名古屋生まれ。名古屋市立工芸高校図案科卒業（五二）。日本デザインセンターを経て横尾忠則、原田維夫らとスタジオ・イルフイルを設立、その後フリーに。宇野と横尾の登場は、六〇年代、ポスターアートが華開く日本の戦後のイラストレーション史における一大エポックとして記憶される。とりわけフェミニニティを謳いあげる宇野作品は、寺山修司の天井桟敷や様々な舞台美術への参加、アンニュイな雰囲気を醸し出す痩身美少女、サイケデリックなボディペインティングなど多彩な表現活動を通じ、そのコケティッシュでマニエリスティックなアートスタイルを洗練させ独自の美的世界を築き上げた。左手から絶えることなく生み出される審美的なイメージは、昭和から今日にいたるまで世代を超え多くのファンを魅了し続けている。本書では妖艶で不羈奔放な異色の「天守物語」を楽しむことができる。日宣美特選（五二）、日宣美会員賞（六〇）、講談社出版文化賞さしえ賞（八二）、サンリオ美術賞（八九）、赤い鳥挿絵賞（九二）、日本絵本賞（二〇〇八）、全広連日本宣伝賞山名賞（二〇一三）、読売演劇大賞選考委員特別賞（二〇一五）など受賞。紫綬褒章（九九）、旭日小綬章（二〇一〇）受章。作品集に『宇野亞喜良クロニクル』『宇野亞喜良ファンタジー挿絵の世界』など多数。

Aquirax Uno

Born in Nagoya in 1934. He graduated from the Graphic Arts Department of Nagoya City Industrial Arts High School in 1952.

He was employed at the Nippon Design Center, Inc., after which he founded Studio Irufiru with Tadanori Yokoo and Tsunao Harada, subsequent to which he became free lance.

The appearance of Uno and Yokoo with their brilliant poster art during the 1960s is remembered as a major epic-making event in the history of Japan's postwar illustration history.

Uno's works chiefly concentrates upon femininity.

Through his partici pation in various stage arts, such as Shuji Terayama's Tenjosajiki Troupe, he was active in varicolored expressive activities, including an atmosphere of ennui engendered by slender, young and beautiful girls and psychedelic body painting.

Thus he constructed for himself a uniquely refined coquettish and manneristic art style aesthetic world.

His aesthetic images, which are continuously given birth from the left hand, continue to mesmerize numerous fans that range beyond the bounds of generation from the Showa Period up to the present.

This volume makes it possible to enjoy the bewitching unbridled nonconforming heterochromatic 'Tale of a Castle Keep'.

He has received the following awards and prizes: Japan Advertising Artists Club (JAAC) Special Prize (1952), JAAC Members' Award (1960), Kodansha Publishing Culture Award (illustration category 1982), Sanrio Art Award (1989), Akai Tori Illustration Award (1992), Japan Picture Book Award (2008), Japan Advertising Federation Yamana Award (2013), Yomiuri Play Award (2015), as well as Medal of Honor with Purple Ribbon (1999), and Order of the Rising Sun, Gold Rays with Rosette (2010)

His numerous publications include: "Aquirax Uno Chronicle" and "The World of Aquirax Uno's Fantasy Illustrations."

山本タカト（やまもと たかと）

一九六〇年、秋田県生まれ。東京造形大学絵画科を卒業（八三）。商業イラストレーターとして仕事をはじめるが、時流に背を向け、長年憧憬してきたビアズリー、クラークなどの十九世紀末美術や鈴木春信、月岡芳年など江戸・明治の浮世絵に連なる耽美世界の追求に没頭していく。
〈平成耽美主義〉を標榜した処女作品集『緋色のマニエラ』で鮮烈なデビューを飾り（九八）、以後彼が生み出すエキゾチックな独自の幻想絵画群は大きな反響を呼ぶことに。耽美小説、幻想小説、官能小説、時代小説などの装幀画・挿絵を中心に活躍しつつ、近年は物語性から離れた大型のイコン的な創作絵画にも領域を広げ、国内のみならず海外の作品コレクターたちの間でも高い人気を博している。「草迷宮」（二〇一四）に続くこの「天守物語」でも、幽艶にして丹誠華麗な挿画をみごとに描き下ろし、現と幻の境界である天守で繰り広げられる数奇な恋物語をみごとに浮き立たせている。
『緋色のマニエラ』をはじめとする作品集は『ナルシスの祭壇』『ファルマコンの蠱惑』『殉教者のためのディヴェルティメント』『ヘルマフロディトゥスの肋骨』『キマイラの柩』『ネクロファンタスマゴリア ヴァニタス』など、いずれも二年おきに個展開催と同時に出版されている。また国内外のグループ展にも精力的に参加している。

Takato Yamamoto

Born in 1960 in Akita Prefecture. He graduated from Tokyo Zokei University Painting Department in 1983. He began his career as a commercial illustrator, but he turned his back on the trend of the times, immersing himself in pursuit of the aesthetic world of late 19th century art, including that of Aubrey Vincent Beardsley and Harry Clarke both of whom he had always been enamored, as well as such Edo and Meiji Period Ukiyoe artists as Harunobu Suzuki and Yoshitoshi Tsukioka. He made a striking publication debut with his "Scarlet Maniera" in which he advocated "Heisei Aestheticism" (1998).

Subsequently, the unique fantasy paintings, to which he gave birth, elicited and overwhelming response. While centering on his activities in the realm of illustrations for book cover and illustrations for aesthetic novels, fantasy novels, erotic novels, and historical novels, in recent years, he has also extended his efforts into large scale original works that depart from the essence of storytelling, resulting in burgeoning popularity among collectors not only in Japan but those throughout the world as well. Continuing from 'Grass Labyrinth' (2014), for the present 'Tale of a Castle Keep,' he has created profoundly elegant and sincerely resplendent original illustrations that brilliantly bring to the fore the subtleties of a love story that wells up in the spirit world of a castle keep situated on the boundary between reality and fantasy.

Beginning with "Scarlet Maniera," he has held solo exhibitions and published anthologies simultaneously at the rate of once every other year, including "Altar of Narcissus," "Allure of Pharmakon," "Divertiment for a Martyr," "Rib of a Hermaphrodite," "Coffin of a Chimera," and "Necrophantasmagoria vanitas."

He has also continued to participate energetically in group exhibitions both in Japan and overseas.

Photo by Hiroshi Nonami

〔編集付記〕

底本は『鏡花全集』巻二十六(一九八八年一〇月、第三刷、岩波書店)および岩波文庫版『夜叉ヶ池　天守物語』(二〇〇六年一〇月、第三十七刷、岩波書店)を使用し、ルビは取捨選択を行い整理しました。

本書には、今日の観点では差別的と受け取られかねない表現がありますが、作者が故人であること、および作品の時代的背景を考慮し、原文通りとしました。

天守物語　本画　山本タカト

天守物語 I
Tale of a Castle Keep I
2016年 400×300mm

天守五重・秋草を釣る五人の侍女
Five Ladies-in-Waiting Angle for Autumn Blossoms from the Fifth Story of the Castle Keep
2016年　300 × 400mm

青 獅 子 頭
The Blue Lion's Head
2016年 382 × 246mm

天守夫人富姫
Princess Tomi, Mistress of the Castle Keep
2016年 300 × 410mm

岩代国麻耶郡猪苗代の城、千畳敷の主・亀姫
Princess Kame, Mistress of Inawashiro Castle of Maya County in the Land of Iwashiro
2016年 400×300mm

朱の盤坊と三人の禿
Shu-no-Banbo and the Three Servant Girls
2016年 300 × 300mm

武田衛門之介の生首を舐め清める舌長姥
The Long-Tongued Old Lady Licks and Purifies the Severed Head of Emon-no-Suke Takeda
2016年 300×210mm

手鞠で遊ぶ富姫と亀姫
Princess Tomi and Princess Kame Play with the Brocated Ball
2016年 φ300mm

鷹を得て矢を射掛けられる富姫と亀姫
Princess Tomi and Princess Kame Capture the Falcon, and are Attacked with Arrows
2016年 300 × 400mm

姫川図書之助登場
Zusho-no-Suke Himekawa Appears
2016年 400×300mm

野衾に雪洞の燈を吹き消される図書之助
A Giant Flying Squirrel Quenches the Flame of Zusho-no-Suke's Lantern
2016年 340×170mm

舌を噛んで死んだ貴女の血を舐める青獅子
The Blue Lion Licks the Blood of Dead Lady who Bit through Her Own Tongue and died
2016年 200×400mm

討手に追われ三度天守に戻る血まみれの図書之助
Zusho-no-Suke Covered in Blood, Returns to the Castle Keep for a Third Time,
to Escape from His Pursuers
2016年 300×210mm

誰の首だ、お前たち、目のあるものは、よっく見よ。
"Whose Head is This!? You Who Have Eyes, Take a Good Look."
2016年 400×250mm

盲目となり抱擁する富姫と図書之助
Now Both Blind, Princess Tomi and Zusho-no-Suke Embrace Passionately
2016年 300×210mm

青獅子の目を開ける近江之丞桃六
Toroku Omi-no-Jo Open the Lion's Eyes
2016年 300×300mm

天守幻影
Phantasmagoria of the Castle Keep
2016年 300×100mm

天守物語 II
Tale of a Castle Keep II
2016年 400 × 300mm

Collage for Publicity

パブリシティ用コラージュ

Princess Tomi
とみひめ
富姫
F0 180×140mm

近江之聖桃六

Toroku Omi-no-Jo

近江之丞桃六
(おうみ の じょうとうろく)
SSM 227×227mm

Like a Pieta;
Princess Tomi
and Zusho-no-Suke

悲゜絵多風・富姫・図書之助
S4 333×333mm

破れた心

Broken Heart
破れた心
SSM 227×227mm

Falcon's Feather
鷹の羽根
SSM 227×227mm

The Lion is Here
獅子が居る
S4 333×333mm

Old Tale
むかしばなし
S4 333×333mm

Like an Autumn Wind
秋乃風のように
SSM 227×227mm

Zusho-no-Suke in Love
こい ずしょのすけ
恋の図書之助
SSM 227×227mm

Princess Kame
亀姫
SSM 227×227mm

Princess Tomi and a Kappa
とみひめ と かっぱ
富姫登河童
SSM 227×227mm

Shu-no-Banbo
朱乃盤坊
SSM 227×227mm

Long-Tongued Old Lady of Chino Plain
茅野ヶ原の舌長姥
SSM 227×227mm

Return from Kozan Temple
高山寺可良乃帰還
S4 333×333mm

Servant Girl, Kikyo
女童　桔梗
SSM 227×227mm

Hagi, Nadeshiko, Ominaeshi
萩　撫子　女郎花
SSM 227×227mm

Now I don't want to let you leave.
帰したくなくなった
297×210mm

Pleasant Fragrance
良いかほり
よ
189×189mm

Paintings
Illustrations by Aquirax Uno

英訳について
凡例

1. 原文にある補足説明のためのカッコ（）のほかに、訳者が日本語のカタカナ読みにつけた英訳には [] を使用しています。

2. 原文にあるト書きはイタリックで表記しています。また英文としての読みやすさを優先し、訳者の判断で台詞のなかの（）内の内容をト書き部分にまとめて訳している場合もあります。

3. 英訳で特に人名が長い LONG-TONGUED OLD LADY は OLD LADY に、SHU-NO-BANBO は BANBO に、LADIES-IN-WAITING は LADIES としています。

なお原文の解釈では、泉鏡花研究者で都留文科大学文学部国文学科の野口哲也准教授にお世話になりました。この場を借りて御礼申し上げます。

参考文献：
Poulton, M. Cody. *Spirits of Another Sort: The Plays of Izumi Kyoka*. (Michigan Monograph Series in Japanese Studies) Ann Arner: Center for Japanese Studies, The University of Michigan, 2001.

加藤めぐみ
（都留文科大学文学部英文学科准教授）

Notes for Translation into English

1. In addition to the brackets () in the original text, square brackets [] are used to explain the meaning of Japanese names or words.

2. Stage directions are written in italics.
 Some notes in brackets of the original text are included in the stage directions for better understanding of the readers.

3. Long names like "LONG-TONGUED OLD LADY," and "SHU-NO-BANBO" and "LADIES-IN-WAITING" are shortened as OLD LADY, BANBO and LADIES.

Here I would like to express my deepest gratitude to Professor Tetsuya Noguchi, Associate Professor of Japanese Literature at Tsuru University for his great help with the interpretation of the literary text of Izumi Kyoka in which he specializes.

Reference:
Poulton, M. Cody. *Spirits of Another Sort: The Plays of Izumi Kyoka.* (Michigan Monograph Series in Japanese Studies) Ann Arner: Center for Japanese Studies, The University of Michigan, 2001.

Megumi Kato
(Associate Professor of English at Tsuru University)

Don Kenny

Born in the American state of Kansas, in 1936. After graduating from Philips University with a double major in music and philosophy, he came to Japan in 1959. While continuing activities as a free lance translator, he studied Japanese traditional theatre and culture at Sophia University and Waseda University. He has translated the plays of Kyogen and performed them in English, appeared as an actor in numerous NHK dramas, and wrote columns on Japanese theatre for the Japan Times.

He attended performances of *Tale of a Castle Keep* with Tamasaburo Bando in 1997. He also created the English subtitles for director Masahiro Shinoda's 1979 film of *Demon Pond*, starring Tamasaburo Bando.

He aptly rendered the style of samurai and feudal period language, that is considered difficult to duplicate in English, to express the unique ghostly world of *Tale of a Castle Keep*.

Tamaki Anakura

Born in Fukui Prefecture in 1973. After taking the doctoral course of the graduate school of Kanazawa University, leaving without officially obtaining a Ph.D. degree, she became curator of the Izumi Kyoka Kinenkan Museum in 2007 and has continued to serve in that capacity up to the present. She is also a member of the Izumi Kyoka Studies and the Association for Modern Japanese Literary Studies(AMJLS). Books she wrote and coedited: *Bessatsu Taiyo, Kyoka Izumi-Magician of Beauty and Fantasy* (Heibon-Sha); *Collection of Theses, Kyoka Izumi*, Vol. 5. Ed. Izumi Kyoka Studies (Izumi Shoin Publishing Co., Ltd.); *Picture Book, Ke-Cho [Eerie Bird]* (Kokusho Kanko Kai)

Izumi Kyoka Kinenkan Museum

Opened in November 1999 on the site of the house where Kyoka was born and spent his boyhood in Shimoshincho, Kanazawa City. It is known as the repository of handwritten manuscripts and letters written by Kyoka, alongside first-edition copies of his literary works, with book designs by Kiyokata Kaburaki, Eiho Hirezaki and Settai Komura, and it introduces the author and his works through a number of Kyoka's favorite items.

these two artists and a new highly refined English translation that exudes a classical fragrance by Don Kenny, in a bilingual Japanese-English publication. People from overseas, who were unable to come into contact with the beauty of Kyoka literature that must be said to have been the unique privilege of people who comprehend the written Japanese language up to this time, will, as a result, find a place in their memory for the name of Kyoka Izumi in terms of an artist who possesses the handicraftsman-like luxuriant and delicate traditional aesthetics of Japan, and a spirit of unfettered self-indulgence that goes beyond the bounds of the common space-time continuum. And this play script, that is still continuously reborn over the past one hundred years, symbolizes Princess Tomi's love for Zusho-no-Suke, providing a comprehension of the "power" of the world of Kyoka Izumi that is built upon protection of one's loved one despite all obstacles and vicissitudes that brings to mind recollections of the source of feminine aesthetics in the context of one's own life.

Tamaki Anakura
Curator of Izumi Kyoka Kinenkan Museum

Visualization of a work of literature will not necessarily be consistent with each and every aspect of the imagination gained from the written word, and it is constantly haunted by this risk.

In particular, it is easy for illustrations to act as a double-edged sword when they achieve a closeness to the original (written) work when compared with other art genres. However, at the same time it is certain that visualization derived from the totally refined sensitivities and exceptional creativity of the painter is able to elicit recognition of the allure that is embodied in the secret recesses lying in all parts of the written words, and to make the reader tremble with breathtaking surprise and excitement.

Two years have passed since the impact of the illustrations for "Grass Labyrinth" created by Takato Yamamoto who deserves to be referred to as a contemporary Ukiyoe artist who advocates "Hesei aestheticism." Aquirax Uno lived alongside of Tatsuhiko Shibusawa and Shuji Terayama during the period of postwar reevaluation of Kyoka, and he continues even today to lead the world of graphic art as a fantasista. This volume embodies an unprecedented attempt to provide enjoyment of the world of "Tale of a Castle Keep" with the illustrations of

So I feel that it is likely her true femininity that Kyoka was drawn to and yearned after for his entire life.

"Tale of a Castle Keep" was published around one hundred years ago in 1917, but, though it has always been considered "the work in which Kyoka had the greatest self-confidence," it was never performed during his lifetime. It was staged for the first time in 1951, after Kyoka Izumi's death. As a result of the publication of a round table discussion by Yukio Mishima and Tatsuhiko Shibusawa in celebration of Kyoka Izumi's birthday on November 4, 1978, (in 1979 in Chuo Koron Publishing Company's 4th volume of Japanese Literature featuring Koyo Ozaki and Kyoka Izumi), it underwent reevaluation by the general public and came to be the most frequently staged of all his plays. On top of which it has continued to be given renewed life on all art scenes, ranging from Shojo Manga and illustrations, to all manner of plastic art objects and traditional handicraft works such as dolls, that most likely far exceeded a level of varied development that even Kyoka himself never imagined.

For this volume of "Tale of a Castle Keep," the most classical method of all those that have repeatedly appeared from his own lifetime down to the present was employed. This approach was deliberately maintained in all aspects of its production from its illustrations to its book design with a stress on ultimate beauty.

Love that Lives Everlastingly
In Commemoration of the 100th Anniversary of "Tale of a Castle Keep"

"I still cannot resolve myself. Oh, what I mean is that I cannot give up hope of saving your life."

　If I were to ask to select one example from those that touch the very souls of those who hear or read the overflow of beautiful language that has established "Tale of a Castle Keep" as the major immovable masterpiece of all the plays of Kyoka Izumi, I would choose this single line of dialogue as it seems to me to express the very essence of the words of all of those that overflow throughout the entire work. It is uttered by Princess Tomi, who rules the fifth story of the castle keep of Himeji Castle, to the young falconer Zusho-no-Suke Himekawa after he sets foot in her spirit world, which no human has ever entered for hundreds of years, when he is being pursued by officers intent on capturing and executing him for a crime of which he is innocent. Tomi is an unearthly and dignified beautiful Princess who has an entourage of specters together with whom she admires a severed human head, while she also falls in love with a living human young man who returns her love to the extent that he begs her to execute him by her own hand. Not only is she unable to bring herself to do so, but she attempts to protect him.

Commentary
Tamaki Anakura

keep on blooming. . . Listen, all you idiot warriors!
(Laugh derisively.) There is a lion here. So make merry,
as though it is festival time. *(As he goes on carving.)*
All you rascally castle warriors, with your lances, your
swords, your bows and arrows, and your guns!

(The Curtain falls.)

Tale of a Castle Keep

TOMI	Dear old man.
ZUSHO	Honorable old man, who are you?
TOROKU	Since you ask, my name is Toroku Omi-no-jo, a toothpick whittler from the Land of Tanba, and I am the one who carved both a peony on somebody or other's comb, and this lion's head here.
TOMI	*(Realizing that she and Zusho are embracing each other.)* Oh, dear me, how embarrassed I am to be seen like this!

Tomi and Zusho cover themselves once more with the cloth body of the lion.

TOROKU	Hmm, you appear, you appear as though you are extremely embarrassed, but still you appear to be happy. Ha, ha, ha, ha, ha! You loving youngsters. *(He strikes a flint to light his long pipe and blows out cloud after cloud of smoke.)* After such pain and suffering, rest yourselves, enter a peaceful sleep. As you do, I will give you a little clearer eyes.

He carves with his hammer and chisel. Moonlight floods the scene.

There, you see, the moonlight shines through on your eyes. *(After carving a little more, he perks up his ears and the sound of voices raised in triumph is heard from below the castle keep.)* Though the world is at war, butterflies dance, and fringed pinks and bellflowers

TOMI You must not commit hara-kiri.
 Oh, but since there is no other way, I will serve you with the final blow, biting off your tongue. At the same time, you must thrust your sword into my heart, my vital spot.
ZUSHO If only I could see your lovely lips as you speak these words to me.
TOMI If only I could see just one of your eyebrow.
 (They raise their voices together, weeping loudly.)
Suddenly a loud voice rings out from behind the pillars.
TOROKU Wait, and weep not, weep no more!
The woodcarver Toroku Omi-no-jo, a gentle old man, around sixty, appears wearing a cloth hat and craftsman robes, carrying a bag of flints and tools, and waving his fan.
TOROKU Beautiful people, cease your weeping.
 (He moves briskly to the altar and caresses the lion's head as he speaks to it.)
 To begin with, I will open your eyes.
Pulling a chisel and a wooden hammer out of his tool bag, he applies them to both eyes of the lion's head.
Both Tomi and Zusho raise their voices in joyful surprise.
TOROKU So how is that? Come now, see!
 Ha, ha, ha, ha! Your eyes are fully open.
 Open in seeming joy. Oh, so you are laughing.
 Who, who is laughing? Ah, ha, ha, ha, ha!

Tomihime
et
Zusyonosuque

	take my life by your own hand.
ZUSHO	Oh, Princess, is what you say really the truth?
TOMI	It is indeed. . . But I want to see your face as you speak these words to me, for just one more time. . . for ours is a love that is found only once in one hundred or even one thousand years of life.
ZUSHO	Oh, I, too, want to see just once more your dignified and lovely face.
	(They cling to each other, embracing passionately.)
TOMI	I need neither past nor future life, all I want is to remain together as we are now.
ZUSHO	Oh, they are calling from below the castle keep.
TOMI	*(Speaking sharply)* Oh, how vexing! If only we have just an instant more of time, I could call on Princess Yuki of the Demon Pond, and another Princess who's like a younger sister to me, in distant Inawashiro to come to aid and assist me.
ZUSHO	I have made up my mind and am ready, so, my Princess, kill me. . .
TOMI	I still cannot resolve myself. Oh, what I mean is that I cannot give up hope of saving your life.
ZUSHO	If you wait any longer, those warrior rascals, my human compatriots will be upon us. So if you will not take my life for me, I will do so myself. *(He draws his sword.)*

TOMI There is nothing more that I can say.
 You must make up your mind and take courage.
 The severed head that I just now handed over to them
 will also disappear the instant that they step outside of
 this castle keep. And the warriors will immediately
 come back here. I myself can ride on the clouds,
 fly with the wind, and pass across the bridge of the
 rainbow. But you, my Zusho, cannot. Oh, how vexing!
 I had hoped that we could wear the bamboo hat and
 straw raincoat, to look like two angels, leaving
 everything up to the dawning of the sun, the rising of
 the moon, and the shadows of the setting sun, causing
 everyone to pay homage to us, but now that I have
 become blind, I cannot even save your life.
 Please forgive me.
ZUSHO I have no regrets! So, please, my Princess,
 take my life with your own hands.
TOMI Oh, there is no way that I can lay a hand on you.
 So instead, I cannot live either, so let us be reduced to
 the dust and soot of this castle keep, become dead
 leaves and wither away together.
ZUSHO Oh, no, for why should you, my beautiful Princess,
 after living so long in this world, become my souvenir
 on the road to the other world?
TOMI Oh, but that is exactly what I truly desire, to have you

ZUSHO Princess, where are you, oh, my Princess?
Tomi stands stock still as though in a trance, not making any verbal response.
ZUSHO *(Pitifully lonely, he gropes about trying to find Tomi.)* Princess, where are you? I have lost my eyesight and I cannot see, Princess.
TOMI *(She weeps silently.)* Oh, my dear, I have also lost my eyesight and cannot see.
ZUSHO Aaah.
TOMI Ladies, oh, my Ladies. . . at least bring some light here. . .
LADIES We have all gone blind. We have all lost our eyesight and cannot see. *(The Ladies-in-Waiting are heard weeping piteously from behind the wall.)*
TOMI *(She falls to the floor and drops the lion's head.)* Both the lion's eyes have been wounded, and every one of us whose life its spirit supports has become blind. Oh, Zusho. . . Where are you?
ZUSHO Oh, my Princess, where are you?
Both Tomi and Zusho grope about until they touch hands, burst into tears, and embrace passionately.

あ〜目が見えない〜

ZUSHO	*(Dashing out from under the lion's cloth body, wielding his sword. The retainers shout insults and cross swords with him.)* Oh, my eyes are blind.
	(They strike him down and pin him to the ground.)
	How mortifying!
TOMI	*(She comes out and stands, holding the lion's head high, with her black hair all awry, and a ferocious expression on her face. She holds the severed head by the hair in her other hand.)*
	Whose head is this!? You who have eyes, take a good look.
	(She throws the severed head violently toward the warriors.)

The warriors draw back in fear, and Shuri approaches the head gingerly and picks it up.

SHURI	By the three treasures.
KUHEI	It is the lord's head. The head of the Lord of Harima.
SHURI	This can be said to be a terrible thing to have happened. How can there be the head of your very self?
KUHEI	What a frightful evil spirit. We must not waste any more time in a place such as this.

The warriors stagger to their feet, and along with the severed head, they exit in extreme confusion and disarray.

KUHEI With all my heart. Pierce it with a lance.

A retainer tries to attack the lion's head, but it begins to thrash about in a crazed manner. The retainer retreats. Shuri and Kuhei and the others take turns attempting to quell the lion's head, but it continues to thrash about, causing them all to retreat.

SHURI Even this wood carving has a soul, just the same as that of a living beast. Aim for its eyes, aim for its eyes.

Kuhei and Shuri join forces and when they pierce one eye each with their swords, the lion falls down, and the retainers pin it down.

The woman had a plain wooden comb with a Miwa peony relief carved on it binding her hair near her forehead, and when she died, it slipped out and fell to the ground. A retainer picked it up and handed it to the lord, who nonchalantly slipped it into his sleeve. He was a rough lord who had no fear of curses. In amusement, he told the lion that if it could make water flow, then make it rise to cover the fifth story of the castle keep, and thus saying, he captured it alive. And he tossed it up here and it became this lion's head. Since that time, this castle keep has become an enchanted place where many strange and weird incidents have taken place.
I have always found them hard to believe, but now that I see it with my very own eyes, it is indeed strange. . .
Prepare your heart for that as you attack it.

on horseback, saw with his drowsy eyes the most lovely woman in the world, who appeared to be from the capital and most unexpectedly appeared in this country town, to escape from the clutches of his retainers and himself and hid herself in that shrine. While he was a falconer from Mount Momiji, he assumed that she was a courtesan or a great lady from the land of the losing side in a battle who had escaped this far, for she was a peerless beauty. So, determined to capture her, his retainers invaded the shrine. and ignoring the claim that she was a married woman, grabbed and tried to bind her, hand and foot, in response to which she bit through her own tongue, fell flat on her face, and died on the spot. At that time, she gazed upon the lion's head, speaking aloud, 'Oh, lion! what a splendid work of art you are! If I but had power like you, I would not have to die at the hand of these hideous brutes.' And during the subsequent three years, there was an autumn flood every year. And it is said that what the mountain priest who came to dispose of her dead body saw was the lion who turned its head upside down and licked the blood of the woman while shedding copious tears at that time. And it is claimed throughout the land that the continued floods were caused by the malicious vengeance of that woman's ghost.

KUHEI	*(Carrying a lantern.)* Oh, so this is what appeared to be a suspicious, amazing, beautiful enchantress.
SHURI	It changes shape, it is bewitched. When the lord said he saw the auspicious omen of the castle that was a crane with the appearance of an angel, he thought that if he sent his falcon to confront it, the falcon would succeed in throwing its ragged straw raincoat off. . . How preposterous!
KUHEI	It is nothing but that despicable Zusho Himekawa who has most certainly and undoubtedly hidden inside the cloth body of the lion. Hey, this is an order from your superior, come out, you traitor, and face this Kuhei Yamazumi.
SHURI	Wait, Yamazumi, it was indeed that rascal who hid there before we arrived. No matter how you call to him, he will not come out. Let's just grab him and drag him out.
KUHEI	Come, all of you and help me.
SHURI	Be careful, for if you act rashly, you could suffer injury. Since times long past, this blue lion has been inordinately formidable. Just listen to its antecedents. Previously, this was on the outskirts of the castle and its surrounding town, dedicated to the titular deity of the shrine on the Mount of Flocking Herons. The castle lord of two generations past, when he was falcon hunting

	tales and rumors. But they are already aware that I have come up here, and just as I speak. . .
TOMI	Yes, that is as you say, so before they arrive, I will hide you from their eyes. *(She raises the cloth that constitutes the Lion's head body.)* Come, come in here with me. . .
ZUSHO	It's impregnable!
TOMI	Oh, but this is soft.
ZUSHO	As you say, it is even softer than silk floss.
TOMI	So take a firm and strong hold of me and stay together.
ZUSHO	Pardon me, I comply.

He embraces Tomi from behind, grasping her sleeves, seeming to lean on her, and she lifts the edge of the cloth forming the lion's body higher and they crawl inside. Tomi folds her hands in supplication to the lion as though asking for its permission and its protection. The pursuers enter noisily, and when they see the lion, they draw back in surprise. At the same instant, Tomi's face disappears beneath the lion's cloth body, making it appear to the warriors that there is nothing on stage but the threatening blue-faced lion's head. The huge number of pursuers includes Shuri Odawara and Kuhei Yamazumi, as well as common warriors bearing lances and long swords, among whom are those wearing light-chest armor.

ZUSHO	and on top of that, draw his sword on you is unforgivable. For a crime of which I have not the least knowledge, people kill each other, though they are the same human beings. I cannot give in to the absurdity of being killed by those same human beings. . . I have broken your interdiction. I have turned my back on my promise to you. So I bow down to receive punishment for my crime. I beg you to take my life quickly.
TOMI	Oh, yes, if I were one of your compatriot warriors, I would indeed take your life. But I beg you to live here forever with me.
ZUSHO	*(Urgently.)* I appreciate your kind words, but even if I should try to live on, my pursuers will absolutely not allow me to do so. So please kill me by your own hand quickly. For you to take my life would be the ultimate satisfaction to me. For I would be deeply chagrined if I were cut down by those rascals. Come, now take my life. . . *(Putting his hand on Tomi's knee.)* For as I speak they are approaching nearer and nearer.
TOMI	Oh, no, I doubt that they will dare to come up here.
ZUSHO	They are scampering up and down the five stories, all over each floor, each stairway, like veritable mice. . . They hesitate in fear of the demons, gods, and evil spirits that they have always been told of in old-wives-

TOMI	Sir Zusho!
ZUSHO	*(Noticing Tomi, he staggers toward her quickly, breathing heavily.)* Princess, ignoring your words of warning, I have come here for a third time. Please forgive my impudence. They are calling me a thief. . . a thief. . . and a traitor, a traitor!
TOMI	I know, I know. No matter how imperative the words of the lord are, for those who had been friends up to that instant to suddenly contradict his own words,

Tomi places one hand on the railing and peers over it down into the stairwell.
Loud voices and footsteps are heard.
Zusho's hair is cut loose and his clothes are drench in blood, and he wields his sword as he emerges from the entrance to the stairwell and glares back downward. His shoulders heave with heavy breathing. He takes a deep breath and drops to the floor in exhaustion.

	Someone's arm has been severed. Oh, another has been slashed across his body. He wouldn't have to continue fighting, but a warrior, who seems to earn a modest income, has been beheaded. What a pity!
TOMI	I'm used to such as all that since the days of Hideyoshi, so why are you making such a fuss?
SUSUKI	I can't help but make a fuss. One man has cut his way through the crowd. It is Sir Zusho, and he has dashed into the castle keep. They are chasing after him. They even drew their lances. *(Dashing along the railing to get a better look.)* Sir Zusho has climbed up as far as the second story. A huge crowd chases after him.
TOMI	*(Rising up on one knee.)* Well then, we must help him.
SUSUKI	Ladies, all you Ladies. . . *(As she calls out, she hurriedly descends the stairs to go below.)*

SUSUKI	Examination of the helmet has begun.
	Oh, I am surprised. His lacquer-like thick eyebrows are twitching and twitching. How would it be to show him the head of his brother that Princess Kame brought you as a souvenir? Oh, his steward is also there. That old man amassed his wealth by causing the farmers pain and suffering, as he went bald. Oh, they are all gathering around Sir Zusho, thinking that some of his accomplishments might rub off on them. Oh, swords have been drawn! What, what, what, oh, oh, Princess, Princess!
TOMI	That's enough!
SUSUKI	No, that is not enough. They are saying that Sir Zusho is a thief, that he is the traitor who stole the precious helmet, a traitor, and that he is of the same ilk as the traitor who cut off the lord's head, even though he is the one who has returned the helmet. . . Oh, how weird human beings are. . . Oh, they have drawn their swords. After showing loyalty and receiving a fief, I wonder if he will allow himself to be cut down without resistance? Oh, he's done it, he threw it at them. I'm so happy. There, you see. The steward has thrown off his cloak. A huge crowd has drawn their swords all at once. Oh, how dangerous! How brave! Sir Zusho has drawn his sword in defense. . .

TOMI	But even so, he says that he is the falconer who was holding the white falcon. . .
	It is fate that brought us together, isn't it.
SUSUKI	I am certain that it is your mutual fate.
TOMI	Somehow, I can't help but thinking so.
SUSUKI	My Princess, even though it is you who say so, I am pleased that you agree with me.
TOMI	I am also pleased that you agree.
SUSUKI	This is also a pleasant greeting. . .
	Oh, what is going on? Suddenly there is a noisy bustling below the castle keep. *(Standing and going to the railing and looking down into the distance below.)*. . .
	Oh, just look for yourself.
TOMI	*(Remaining seated.)* What is happening?
SUSUKI	A huge group of warriors is building a bonfire.
	Oh, and Takeda, the Lord of Harima is present, sitting on a stool. That lukewarm, dull-minded, nosy, and short-tempered man has grown impatient waiting for the return of his messenger, and has come out thus to meet him. And, oh, I think, yes, I do, I see Sir Zusho, looking very small. Oh, Princess, among the tadpoles, with his family crest in the form of a water lily in full bloom standing at the edge of the water, he is so very beautiful. . . Princess. . .
TOMI	What do I care?

TOMI	*(She falls into a brown study, with her elbow on the desk and her hand on her cheek, and then she speaks to the lion's head.)* That man. . . Please give him to me.
SUSUKI	*(Entering quietly.)* My Princess.
TOMI	Oh, it's you, Susuki.
SUSUKI	What a fine man he is!
TOMI	I am so embarrassed that I did not know him, that I never set eyes upon him before.
SUSUKI	Since he is the type of man you have always wanted to meet, why did you let him go back?
TOMI	Because he wants to continue his life, and he said he would resist me keeping him here.
SUSUKI	Since it would only be a matter of keeping him here with you, after all, it would not mean that you would take his life from him.
TOMI	I think that the way they see it is that staying here would not constitute staying alive.
SUSUKI	With your allure and power, you could easily have forced him to stay, so what could his resistance do in the face of your desires?
TOMI	Oh, but I do not want to reveal my allure to him myself. And forcing people to do things is what people like the Lord of Harima do. But true love is a heart to heart matter. . . *(Lightly.)* Is it not, Susuki?
SUSUKI	Is that so?

	hard to believe my own eyes, and I have only set eyes on it at the time of airing out once a year, it looks to me to very like the greatest treasure of the family, the blue dragon helmet.
TOMI	That is absolutely what it is.
ZUSHO	*(Looking bewildered but speaking abruptly.)* More so than before, I must now rise up and go with heartfelt speed. So I now take my leave.
TOMI	If you should come here once more, I will definitely not let you go back again.
ZUSHO	I swear. . . but that goes without saying.
TOMI	Fare thee well.
ZUSHO	Fare thee well. *(Holding the helmet aloft, he disappears hastily down the stairs.)*

very suspicious of everything. And this is particularly the case with cowardly, timid and self-centered lords. No one will likely believe that you came up to this fifth story and met me here. So for you who are pure and refreshing, I will give you a gift for remembrance. . . *(She goes quietly and takes up the helmet that was placed on the altar earlier.)*
Here, take this to remember me by.

ZUSHO What an unexpected treasure, and it would be conversely rude of me to refuse your offer, even though it is an incredibly precious and glorious helmet.

TOMI While it is embellished with gold and silver, it is not so very skillfully made. But it is an item that is most important to Takeda. . .
Do you recall having seen it before?

ZUSHO *(Scrutinizing the helmet questioningly.)* While I find it

TOMI	Oh, what gentle words you speak! They make me even more reluctant to let you go. *(She grabs his sleeve.)*
ZUSHO	*(But he coldly and abruptly pushes her away.)* No matter how you try to keep me here, I will continue to resist.
TOMI	*(Smiling.)* Resist me?
ZUSHO	That, I must do.
TOMI	Oh, how brave, how magnificent! You, young man, who resembles the lion, please tell me your name.
ZUSHO	Your request is like a dream to me, so dazzling that I even forget my name and lose conscious. My name is Zusho-no-suke Himekawa.
TOMI	What an endearing and happy name! I will never forget it.
ZUSHO	From this moment on, whenever I pass below your castle keep, I swear that I will offer up constant prayers to you. . . Farewell. *(He gets briskly to his feet.)*
TOMI	Oh, Sir Zusho, wait a moment longer.
ZUSHO	Then I must, and is there a rule that says that, in any case, you will not let me go back alive?
TOMI	Ho, ho, ho. It is different here from the household of the Lord of Harima. Everything here is determined by my own heart alone. There are no other rules here.
ZUSHO	Then for what did you call me back?
TOMI	I have a parting gift for you. . . Human beings are so

formality of apologetic words. If you are capable of comprehending even a small part of what I am saying, you must no longer return to that world of the second, third, and main castle walls, the lord himself, his harem and all his household who cannot grasp the significance of what I am saying. Rather than the platinum, the gold, the jewels, the corals, and the way of thinking of fiefs of a thousand or even ten thousand bales of rice, I'll devote myself to you. In place of a lord who makes you commit hara-kiri, I give my heart to you. I'll give my very life to you. So you must not go back, away from here.

ZUSHO You put me into a state of confusion, Princess. My heart that has always been as hard as gold and steel for my lord's benefit, is beating with such wild waves, that I am overwhelmed with anguish. And I find it impossible to make a clear decision. I want to listen to my parents, be taught by my teacher, and I also feel obliged to listen to the admonitions of books. Thus I must say farewell to you.

TOMI *(Sighing.)* Oh, so you still have attachments to the mundane world. In that case, go back where you came from. *(Putting the candle into his lantern.)* Here you are.

ZUSHO I go with a heart filled with confusion. Please have pity on a thoroughly vacillating and hesitant human being.

ZUSHO	But the falcon did indeed get loose and fly away.
TOMI	Oh, how frightful is the relationship between lord and retainer. Does not such an action mean exchanging a human life for the loss of a falcon? Well then, if you believe that it is the way of lord and retainer and that you mistakenly blame yourself for the mistake, there is nothing to be done about it. But since it was Harima's order, the result is Harima's mistake. First of all, it was not you who lost the falcon. It was I who took it from you.
ZUSHO	Oh, no, it was you?
TOMI	Indeed it was.
ZUSHO	Well, then, I despise you for it. *(Grasping the hilt of his sword to draw it.)*
TOMI	First of all, who do you think the falcon belongs to? Falcons have their own world of falcons. In it there are the pure frosty dews of the forest and the refreshing morning storms and evening winds of the sky. They definitely are not the property of human beings. It is only the excessive conceit of lords that such a falcon could be their possession. Do you not agree?
ZUSHO	*(Pausing for a moment to ponder.)* Oh, lovely, most noble, most un-calculably majestic Princess. . . You put me at a total loss for words.
TOMI	Here, here, there is no need for such complexity and

TOMI	*(Holding a candle)* Now I don't want to let you leave, I intend to keep you here with me.
ZUSHO	Huh?!
TOMI	You said that you were ordered to commit hara-kiri by Harima. What crime was it for?
ZUSHO	I was carrying on my arm my lord's favorite and Japan's best white falcon, and allowed it to fly off to this castle keep. It was for that blunder, that negligence, that I received his order.
TOMI	What's that you say? It was for the blunder, the negligence of allowing the falcon to fly away. . . ? Oh, what strange things human beings blame each other for! It was not likely you who selfishly put the falcon into contact with a bird to prey on. It was because the Lord of Harima saw one of the most beautiful birds in the world in the rafters of this castle keep that, from a desire to capture it, he selfishly let the falcon go, and then accused you of the crime?
ZUSHO	We are lord and retainer, and the way of loyalty is to risk my life to accomplish anything that my lord orders me to do.
TOMI	That way has become twisted and distorted. Is not the following of a mistaken order, in effect, an act that causes your lord to take a mistaken step on that path?

	have become crippled, and I would lose my reason for living as a man. And when I looked back up to this fifth story, I could see a dim light. So I made up my mind that, even if it means incurring your anger and losing my life, as a man, I felt like it would be more advantageous to ignore your warning than it would be to risk suffering an injury from falling down the stairs, thus I chose to come back here.
TOMI	*(Smiling with pleasure.)* Oh, what a refreshing heart is yours! And how courageous you are! I will light your lantern for you. *(Getting to her feet.)*
ZUSHO	Oh, no, I am too overcome with awe to have you do that for me. I will just light it myself.
TOMI	Oh, no, I say, this light is the same as that of the morning star, the Big Dipper, the dragon light, and the jewel light, so it would be quite impossible for you to light your lantern by yourself.
ZUSHO	Oh. . . *(He looks intently)*

Tomi eagerly takes the candle out of his lantern, and lights it with her candlestick. Then she holds up her candlestick and gazes at Zusho's face, almost swooning in ecstasy, speaking while still holding her candlestick to shine on his face.

The sound of a temple bell is heard.

Tomi calmly returns to her seat. Zusho gropes about in the darkness until he reaches the hole in the floor. (Pause). He disappears into that hole. After a time, he enters the stage by the same staircase from which he arrived earlier. He unhesitatingly approaches Tomi and touches the floor.

TOMI	*(Speaking first in a gentle tone of voice.)* So you have come back, I see.
ZUSHO	Yes. And I apologize for causing such a ruckus in the shadows of the night.
TOMI	What did you come for?
ZUSHO	When I had descended back as far as the third story of this castle keep, I met up with something that I thought to be a giant flying squirrel that was as big as a kite, but it was actually a huge black-winged bat, and its wings quenched the flame in my lantern, for which reason I lost my way in the pitch darkness and came back here to light my lantern anew.
TOMI	Was it for nothing more? . . . Did you forget my admonition to never come back here again?
ZUSHO	The crescent moon was hiding in the shadows, not showing so much as a needle's width of light, so if I had tried to descend, it would have been in total pitch black darkness. So thinking that If I were to take a misstep and fall down the stairs, I would likely

姫川図書之助

He picks up his lantern and turns to exit quietly. Tomi picks up her long pipe, and when she taps it loudly, Zusho stops at the edge of the wooden floor for an instant, then he quickly moves to the entrance to the stairwell, with his lantern headed downward, and is hidden below.
The sound of a temple bell is heard.
Suddenly a huge monster appears, all dressed in black and with a black face, as though creeping across the roof tiles and down the branches of the trees, finally arriving in a corner of the stage, and kneeling down near the hole in the floor.
The sound of a temple bell is heard again.
Zusho rises up out of that hole in the floor.
Tomi stands and peers down at him, and when he arrives at the downstage railing made of thick red drum ropes, he stops and raises his lantern and looks high up into the castle keep. At that instant the huge monster peers at him and blows out the light in Zusho's lantern. Zusho quickly turns around. The huge monster opens its arms to both sides to prevent him from passing.
The sound of a temple bell is heard once more.
The Ladies-in-Waiting come on through the lift curtain, dressed in battle gear, holding daggers and halberds. Zusho draws his fan out of his waist sash, and pushes the huge monster aside with it. He avoids being struck by the daggers and matches the strokes of their halberds. Finally, he chases everyone off, lifts up his fan at the edge of the lift curtain, and looks sharply upward to the castle keep.

	have seen you?
TOMI	Make certain that you do so. Because, unless I have gone out, I am always right here.
ZUSHO	It is a great honor for me that you gave me such an order, and I swear as a warrior to tell him. . . Excuse me, I will leave now.

	Make certain that no one else ever does.
ZUSHO	Oh, no, as long as I do not come here, there is likely no one else among those attached to the entire five hundred thousand rice-bale producing fief who would so much as venture to come here, because they all value their lives.
TOMI	And you, do you also not desire to preserve your own life?
ZUSHO	There is a particular reason that I have incurred the displeasure of the lord, and just at the point that I was to be incarcerated, far from his eyes, since there was no one else who was willing to come up here to the castle keep, I was suddenly called into the lord's presence. And I was informed that just at the point where I was about to be ordered to commit hara-kiri, the pattern of things had suddenly been altered.
TOMI	So when you complete your duty, will you be let off from committing hara-kiri?
ZUSHO	That is what I have been promised.
TOMI	While I do no care about whether people live or die, I would not want anyone to commit hara-kiri. I have a horror of hara-kiri by warriors. But, most unexpectedly, I have saved your life. . . There is nothing wrong with that. And tonight is a fine night. So just go back where you came from.
ZUSHO	Oh, Princess.
TOMI	Are you still here?
ZUSHO	Yes, and though I realize it is a rude thing to request, is it all right with you for me to convey to my lord that I

	away... And is that the only thing that you came here for?
ZUSHO	I was not ordered to do anything else than that.
TOMI	Were you not ordered to come up here and see how matters stand?
ZUSHO	No, I did not receive such an order.
TOMI	And now that you have seen what is here, isn't there anything else that you want to do?
ZUSHO	The castle keep belongs to my lord, so no matter what the state of things here may be, there is absolutely no way that anything I myself might want to do could be carried out.
TOMI	Just a moment. This castle keep belongs to me.
ZUSHO	Well, it may in fact belong to you. But the lord, being the lord, may well have a different opinion on this matter. But, in any case, it definitely does not belong to me. So, being a thing that does not belong to me, I do not have the least intention to do anything without a specific order from my lord.
TOMI	What cool words you do speak! If that is your heartfelt purpose, you will indeed return unharmed. I will also return you safely.
ZUSHO	For that I am eternally grateful.
TOMI	And from now on, no matter what Harima may say, you must never come here again. This is not a place where human beings should come...

and his eyes alight on the form and figure of Tomi. He quickly puts his hands on his sword hilt and scabbard, ready to draw, but steps gingerly backward in respect.

TOMI *(Pause.)* Who are you?

ZUSHO Ha! *(Quickly bowing with one knee on the ground.)* I am. . .

TOMI *(Tomi turns only her head around to look over her shoulder, without speaking a single word.)*

ZUSHO I am a warrior who serves as one of the retainers of the lord of this castle.

TOMI What did you come here for?

ZUSHO For the past one hundred years, no living being has climbed higher than the second and third floors of this castle keep, no one has ever come up here to the fifth floor during that time. But tonight, in accordance with the orders of my lord, I have come to have a look around here.

TOMI Just to have a look?

ZUSHO Just a while ago, my lord's favorite and the best falcon in all Japan got away and flew up here to this castle keep and hid inside. So he ordered me to come here and find it for him.

TOMI Things with wings are not as lacking in freedom as human beings. You can say that they can fly as they please five hundred or even one thousand leagues

A lonely darkness invades the stage for a while, then a flame reveals the lovely presence of Tomi, who is now all alone on the stage, with her back to the audience, facing the lion's head, as she reads a long scroll on a desk in front of her. After a brief pause, Ominaeshi brings on a shining robe that she quietly places around Tomi's shoulders and helps her put her arms through the sleeves, after which she kneels with her hands on the floor, bows, and exits.

<div style="text-align: center;">
Where does this narrow path lead?
This narrow path,
It is the path to the Tenjin Shrine
This narrow path.
</div>

In one corner of the stage, there is a stairwell that leads down to the lower four floors of the castle keep. First a lantern appears and brightens the surroundings. Finally, a handsome young man with thick eyebrows and the look of a brave warrior appears, wearing a black silk robe decorated with family crests, light green wide trousers, and a pair of short and long swords at his waist. His name is Zusho-no-suke Himekawa. He looks up toward the roof, listening to the song that reverberates throughout the air, and then casts his gaze around the corridor. His lantern lights up the surroundings and he is quite surprised at what he sees. His eyes finally fall on a screening partition that stands in the direction in which he is moving. After a moment of indecision, he makes up his mind and proceeds toward the partition

KAME	Not to worry, not at all.
TOMI	Ho, ho, ho. *(Laughing.)* Come, everybody, light sparklers, and that will make them think that the gunfire has made our castle keep catch on fire, making them so shocked that they will stop shooting.

The stage darkens a little, and the sound of rifle-fire stops. Tomi and Kame Laugh joyously. Ho, ho, ho, ho, ho.

TOMI	Just look there now. It is alright to let two or three spots burn that look to be combustible. Princess Kame's road torch will light the way.

The stage goes dark.

KAME	Thank you for your kind thoughts. Now, I will be on my way.
TOMI	Fare you well then.

She drops the straw raincoat and a white falcon flies up into the castle keep and alights on her arm. Voices raised in amazed surprise reverberate from the ground below.

KAME My dear Princess, how refreshingly cool!

TOMI With this falcon, we can toss the ball and it will retrieve it for us. . . Play with it to your heart's content.

KAME I will do as you say.

(She wraps the falcon in her sleeve and dashes toward the stairs ahead of everyone else, and after mounting two or three steps, she turns around, and is just about to transfer the falcon to sit on her arm.)

Oh, the stinging bugs have arrived.

At the same moment, she drops her sleeve down, and a single arrow drops to the floor, an arrow that was shot from below by the falconers.

TOMI Oh! *(At the same instant, she twists her shoulder so that her upper body is facing upstage, and when she faces forward again, she has caught arrows, that were shot from below, in her mouth and in her free hand.)*

How presumptuous!

Suddenly the sound of many rifles firing repeatedly is heard.

SUSUKI Come, everybody!

The women gather and form a barrier.

BANBO Here, Old Lady, help me.

(Standing in front of Princess, with his arms open wide to protect her.)

KAME	Now, my Princess, it's your turn to throw to me.
TOMI	Right.
OLD LADY	Oh, I hope to see you again soon.
TOMI	*(Leading the others on through the corridor, nodding as she peers down at the distant ground below.)* Oh, the falconers have come back.
KAME	*(Peering down.)* When I arrived a bit ago, they looked like a single-file row of ants, dashing through the pine-lined road like bullets shot from rifles. Oh, I say, and the lord who so resembles the severed head is riding with his back extended proudly as he enters the castle citadel.
TOMI	That is the Lord of Harima.
KAME	Oh, look! He has a fine falcon with wings that are as white as snow.
TOMI	Uh, huh. *(Touching her chest lightly.)* My dear Princess. . . *(Pause)* Shall I take that falcon from him for you?
KAME	Oh, why give it to me?
TOMI	Leave it to me. Only, I, the Lady of the Castle can accomplish such a purpose.

She takes the straw raincoat and wraps it around her shoulders, causing a flock of beautiful butterflies to dance assiduously around the straw raincoat, making it appear that she has spread her wings.

Now to human eyes, it looks like a crane wearing a feather cloak.

balances it high in the air as he dances, raising his knees and stamping in rhythm while singing.

> Cutting down the enemy
> like flashes of lightning
> Setting even stones and boulders flying up
> Like spring rain
> And being the natural result,
> Conquering the demons
> To protect the Emperor
> Before they can even so much as approach him.

It is time for Princess Kame to depart.
(Voices are heard from the shadows.)
Everyone sits where they are and listens. Shu-no-Banbo quickly puts his sword back in its scabbard, puts the helmet back where it was.

KIKYO If it's a peaceful omen you want, we have one. Lady Ominaeshi, Lady Nadeshiko, please get to your feet.
Both stand.

> If someone should ask you
> What the name of this place might be,
> Tell them it's the post town
> Of Fuchu in Suruga.
> Good place to care for others
> Kake River post town lodging.
> A place where pheasant hens
> Are caught with the greatest of ease.
> Hunt her down and clasp her tightly,
> Soft and sweet, soft and sweet,
> Sweet little pheasant,
> Such sweetness, such softness makes
> The heart strings quiver.

BANBO Well done, well done.
OMINAESHI So now, Sir Priest, it is your turn. Come, come.
KAZURA Come, get to your feet.
BANBO Borobon, borobon. So now I give in to your request.
The five Ladies-in-Waiting stand and open their fans, and line up around Banbo who pours rice wine for them, then he quickly draws his sword, catches ahold of the helmet with the tip of his sword and

Ladies-in-Waiting push him and he falls down.)
It will produce peaceful omens.
KAZURA That may produce peaceful omens, but your story is not interesting in the least.
BANBO *(Shaking his head.)* Borobon, borobon.
The ball-bouncing song is heard.

> I have three older sisters,
> One is good at the small shoulder drum,
> Another is good at the large stick drum,
> And the best of them is in Shitaya
> She is the most chic of everyone there,
> She buys a sash with two gold pieces,
> With three gold pieces, she buys fastening cords
> That she wraps round and round,
> Leaving seven tassels hanging down,
> Then in the folds, she writes the alphabet.

KAZURA Come, warrior priest, are we not a fine group of Ladies of Reeds from Yoshino, who pour rice wine for you? *(Opening her fan and using it like a pitcher.)*
BANBO Borobon, borobon. *(Opening his fan and using it like a wine cup.)* Oh, it's full, it's full. It is full to the brim. So, please entertain me with a song. . .
It should be a peaceful omen.

and he has lovely ladies on both sides. The road to love is the depth of the darkest night. I, who have endured the most severe ascetic training, in the fields and the mountains, if I pray on these sacred prayer beads, it will produce peaceful omens. The iris blossoms under the bridge, who were they planted by? Borobon, borobon, borobon-no-borobon. He chased five Ladies-in-Waiting who act excited as they run away from him. Borobon, borobon, borobon, borobon. *(Finally the*

OLD LADY I say, even though there are such rice wines as Akebi, Yamagumi, Yamabudo, Hand-made monkey wine, Mountain-peak honey wine, Sweet mist ant wine, and Morohaku wine, to witness you two playing with the ball, even if it were only to listen to your song as you play, it would be the elixir of long-life to me. When you get to be as old as me, you forget all desire and wealth, and all you want to do is achieve long life.
BANBO Well, Old Lady, even so, do you still have desires?
OLD LADY You hateful warrior priest, be careful, or you may get licked on our way home. *(Rolling out her long tongue.)*
BANBO *(Covering his head with his arms.)*
 Oh, somebody help! My horn withers!

The Ladies-in-Waiting laugh.

OLD LADY Come on, then, I will accompany you.

Tomi leads the way, followed by Princess Kame, Susuki, and the young servant girls, leaving behind the five Ladies-in-Waiting and Shuno-Banbo.

KIKYO Come now, warrior priest, let us relax and enjoy ourselves.
BANBO What are we to do if we don't relax?
 Here we go, alley-oop! *(Sitting down on the floor.)*
HAGI Here, now tell us an interesting story.
BANBO How could I refrain? *(Using his fan as a prop to illustrate and accent his narration.)* So a warrior priest is a warrior priest – his tiny black hat is his helmet,

	inside.) Truly, this helmet did not die from piercing.
TOMI	So forget about it. Kudzu, put it over there for a while.

As she is ordered, Kudzu takes the helmet and places it beside the lion's head.

	When you set out for home, I will give you a souvenir that I am certain will please you.
KAME	But, my dear Lady, let's hurry up and play with the ball as we promised.
TOMI	Oh, yes, let's play with it indeed. . . Let's go over there. . . Because when the falconers of castle lord is incessantly pursued by the wind and rain and they arrive at the castle entrance, you have such a lovely and resounding voice that if they hear it echoing from this castle keep, they will cause an unbearable chaotic ruckus all over again.

All of Kame's servant girls rise to their feet.

	Now it is time for you, warrior priest, to enjoy a drink with the Ladies-in-Waiting.
BANBO	That derives from the benevolence of Goddess Kissyo. *(Putting his hands on his thighs, he bows.)*
KAME	Oh, and, Old Lady, you do not need to come with us, either. So just stay here and join the others in a drink. . . The princess and I will be able to take care of ourselves just as we like.
TOMI	It is just as you say.

Kikyo picks up a helmet decorated with a hoe-shaped crest looming over a gold-headed dragon and five neckplates, and she places it on the floor in front of Tomi and Kame.

TOMI	Listen, this helmet with the five neckplates is a treasure that has been passed down in this castle as a family heirloom of the Lord of Harima, and it has been kept under nine locks in the seventeenth secret storehouse. And since I am so glad to see you today, I have brought it out with the intent of presenting it to you. But I have become quite ashamed of my souvenir because of the extremely thoughtful souvenir that you have brought me. So I just thought that I would, though most apologetically, at least like to show it to you.

KAME	Oh, no, it is so wonderful that it dazzles my eyes.

TOMI	I won't give it to you, though. Because, first of all, it has been kept in the storehouse for such a long time that it smells moldy. Its musky fragrance has completely dissipated. And though it would have been good for someone like the great Lord Nagato Kimura at the fall of Osaka Castle to wear it. . . behind the lines of a winning battle some coward appears to have worn it to take shelter from the downpour of arrows. Just have a look for yourself.

KAME	*(Turning it upside-down and peering at the shining wires*

Tale of a Castle Keep

KAME	Oh, Princess, how I envy you! *(Gazing intently at Tomi.)*
TOMI	Huh!?
KAME	You have your lord to protect you.

(Pause) Tomi and Kame smile at each other.

TOMI	Lies become truth. . . Those of both of us. . .
KAME	I am not in need of anything at all.
TOMI	You want this sort of man, don't you. . . Oh, speaking of men, Princess Kame, I have something I want to show you. . . Lady Kikyo. . .
KIKYO	What is it?
TOMI	Bring that thing to me.
KIKYO	As you say, My Lady. *(Getting to her feet.)*
BANBO	*(Suddenly.)* Oh, Old Lady, don't become infatuated with the lion's head. That would be a most indiscrete thing for you to do.
OLD LADY	*(She turns to face the lion's head and gazes at it intently, from one side to the other.)* I'm old and the lady of this castle has granted me permission, so it is no wonder that I have become infatuated.
BANBO	Oh, well, there is nothing against you becoming infatuated, but, Old Lady, standing where you are, your tongue can reach it. *(Laughing sardonically.)*

The Long-tongued Old Lady inadvertently turns to face forward and puts her hands over her mouth. The Ladies-in-Waiting giggle softly.

	forgotten that the needle is still stuck in his throat.
	(Raising the head by the topknot.) What would I have done if it had pierced your lovely throat?
TOMI	Wait just a minute! After you have gone to such trouble to bring his head to me as a souvenir, if you draw the needle out, Emon-no-suke might just come back to life.
BANBO	That's just as you say.
TOMI	I will be careful. Let me have it.
	(She holds out her fan and receives the severed head on top of it.) Listen with care. This man who you people claim to be the spitting image of the Lord of this Himeji Castle, the Protector of Harima, is a blood brother to the Lord himself.

The women all exchange surprised glances.

 I will offer it to the lion's head.

She carries the head herself and places it in front of the lion's head. The lion's head opens its mouth, showing its fangs, and quickly gulps it down, causing the lord's severed head to complete disappear from view.

KAME	*(Holding her fan to cover her face and peering out from between the bones.)* Oh, you are right on, indeed. All the Ladies-in-Waiting gaze passionately at the head without blinking. All of them look like they want to have a bite.
SUSUKI	You, too. . . All of you have a good look for yourselves. This head that Princess Kame has brought here— does it not closely resemble the lord of this Himeji Castle?
KIKYO	Indeed, it is his spitting image.
TOMI	*(Nodding her head.)* So Princess Kame, could it be that this souvenir, is it possible. . .
KAME	Yes, it is indeed the head of Emon-no-suke Takeda, the Lord of Inawashiro's Kame Castle to whom I lend shelter.
TOMI	Oh, my dear friend. . .*(Pause)*. . . So you have done this for me? . . .
KAME	It was no bother at all. And, as for me, though nobody else know this, when I departed from the castle, he had his head on the lap of his mistress and was drinking rice wine. He had a very bad greedy character for a lord. And when he gulped down a mouthful of carp soup, there was a needle in the guts of the fish, and it stuck in his throat, and he died on the spot, that needle will likely disengage itself from his throat any minute. *(Dropping her fan in surprise.)* Oh, dear, I had completely

BANBO Don't talk such foolishness. The equinox is long past. . . Well, now, My Lady, when this Old Lady licks anything with her unfurled tongue, everything including birds, beasts and human beings melts and disappears, leaving only bones behind. . . And that is the reason I did not mention it earlier, but the face of your souvenir has, before we noticed, become long and thin.

But even so, thanks to the benefits of the Old Lady's mistake, unexpectedly, the face that was altered by death has returned to what its owner looked like before. . . My Princess, you too have a look.

skirt, and when she reaches the head-bucket, she grasps the severed head with her wrinkled hands, shoves her white hair out of the way, opens her huge mouth, bites the end of the neck with her blackened teeth, reels out her meter-long tongue, and licks the blood off the severed head.)

How filthy! *(Lick, lick.)* How filthy! *(Lick, lick.)*
How very filthy! So very filthy. Oh, how delicious! How very filthy!
Oh, so very filthy. But so very very delicious.

BANBO *(Stopping her quickly.)*
Here, Old Lady, don't sink your teeth into it,
for there won't be any left for others to eat.

OLD LADY What are you talking about?!
(Looking exhausted as she rearranges her robes.)
Terrible thing about old age is that I recently find that my teeth are so bad that I can't swallow either a human head or the end of a pickled radish unless it is chopped up in small pieces. Left as it is, I can't even bite off a mouthful of a sweet golden sea bream cake.

BANBO	Oh, but wait! *(Raising his hand to quiet them.)* You quarrel in such a friendly manner that your flowery words fly back and forth between you like butterflies. What a lovely sight to witness. . . While this is not for me to say, My Lady, I am certain that this is a thing that you will not find in any way displeasing.

He removes the cloth wrapping, revealing that it is a bucket for a severed head, and he pulls a pale man's head out by the hair, and plops it down.

	Oh, sorry, but it leaked a bit of juice on the way here. *(The head is cover with blood.)* Here, Old Lady, Old Lady, I say.
OLD LADY	Yes, yes, yes, yes.
BANBO	The gift is soiled. It looks like a sea-perch with its scales shaved off and washed in pure water by a inept fishmonger, but, of course, that is definitely not what it is. Old Lady, wipe it clean and purify it before we offer it to the Princess.
TOMI	*(Still holding the pipe, she looks sharply at the face of the severed head.)* You don't need to bother, as it will be tastier covered with blood.
OLD LADY	That which has leaked out is juice that was pent up inside, so there is nothing to worry about. But it is unsightly, most unsightly to gaze upon. Here, here, I will clean it up. *(Creeping forward in her red trouser/*

草靈ヶ原の女長老

TOMI	But still you are so sweet. *(Putting her arm around Kame's shoulders, she looks back at and speaks to the servant girl who is attending Kame.)* Here, let me see the ball. *(Taking the ball.)* Oh, how lovely! But you might have brought one for me too. . .
BANBO	Aaah. . . *(Holding out the wooden bucket wrapped in a white cloth.)* The souvenir that the princess chose so carefully for you is this. While I realize how rude it may seem for me to say, it is so special that I think that it will please you well. . . What do you say, Princess? *(Looking to see how Kame reacts.)*
KAME	Oh, open it, we are with my precious friend, so there is no need to stand on ceremony here.
TOMI	Oh, how happy that makes me! You are mean, my dear Kame, but what is inside? Some smoke from the summit of Mount Bandai, or a will-o'-the-wisp?
KAME	Something like that. Ho, ho, ho, ho, ho.
TOMI	I don't want anything like that.
KAME	Then I won't give it to you.

OMINAESHI (*Bringing a long narrow pipe and tobacco.*)
 Here, My Lady.
TOMI (*Taking a puff on the pipe and then handing it to Kame.*)
 I hear that you take a little recently.
KAME Yes, a bit of both.
 (*Taking the pipe and miming drinking with her left hand.*)
TOMI Bad girl! (*Smiling again.*)
KAME Ho, ho, ho! But that doesn't mean that I think of you as my husband. . .
TOMI What a shameful thing to say!
 But I'm surprised that you were able to make the trip all the way from Inawashiro here to Himeji, a trip of what must be around five hundred leagues. . .
 and you, Old Lady. . .
OLD LADY As you say, Madam. . . But as we were wafted along over the sea and mountains by the wind, it didn't take us even half a day to get here, moving along from post town to post town, for five hundred leagues. . . actually it was a little more than that, more like five hundred and thirty leagues.
TOMI Oh, I see. (*To Kame.*) And it is amazing that you came all this way just to play bouncing ball with me.
KAME That I did, and this is why you are so very fond of me.
TOMI Oh, how impudent!
KAME Think what you please.
 (*Dropping her fan in a fit of pique.*)

eagerly awaiting our princess.
Tell the Long-tongued Old Lady
to convey this to her.

First a servant girl appears from the top of the stairs, bearing a beautiful brocaded ball on both her sleeves. Next comes Princess Kame, wearing a long-sleeved kimono and a gorgeous outer robe, and her hair is coiffed in a high pile with gold hairpins, and she carries a fan in her hand. Also, she is followed by a servant girl carrying a protective sword. Finally, comes the Long-tongued Old Lady wearing a frayed and yellowed cloak and a faded red trouser-skirt. Princess Tomi then appears with her Ladies-in-Waiting and arrives at her seating place.

SUSUKI *(Looking up at Princess Kame.)*
Welcome, Princess.
(And bowing to her along with all the Ladies-in-Waiting.)

KAME Forgive my intrusion.

She moves gracefully and sits down beside Tomi, and they move closer to each other so their knees are almost touching.

TOMI *(With a friendly smile.)* Princess Kame.

KAME Oh, dear Princess, how good to see you after such a long time!

TOMI I'm so glad to see you too.
(Pause.)

GIRL 1	I don't know you.
GIRL 2	Beee. *(Sticking out her tongue at him.)*
BANBO	What is this!?
	(Taking a firm stance, and calling out loudly.)
	Hello in there, is anyone about?
SUSUKI	What do you want? *(Appearing from the wall.)*
	Where do you come from?
BANBO	I reside near Aogowa on Jumonji Plain in Aizu County of the Land of Iwashiro. I am the shape-changing warrior priest of Oshu, and the master of Inden Hall, and my name is Shu-no-Banbo. In other words, I have come as a retainer of Princess Kame. So please announce me to the mistress of this castle, Princess Tomi.
SUSUKI	Thank you for going to the trouble of accompanying the Princess, but where is she?
BANBO	*(Turning his face upward, looking up toward the ceiling.)* Her palanquin has already arrived in the rafters of the roof, and she is preparing to appear from there.
SUSUKI	My mistress has been eagerly awaiting her arrival.

Susuki claps her hand and in response, three Ladies-in-Waiting appear, and bow with their fingers politely on the floor.

	Ask her to come in quickly.
BANBO	*(Speaking toward the sky.)* You who accompany the palanquin, they are already

木乃伊蒡

Shu-no-Banbo enters, descending the stairs that lead up into rafters. He is the chief retainer of Princess Kame who is the mistress of the Inawashiro Castle of Maya County in the Land of Iwashiro. He is dressed as a warrior priest, with a rhinoceros horn on his head. His eyes are round and protruding and his face is bright red, while his arms and legs are blue-green like gourds. He carries a small wooden bucket that is wrapped in a white cloth under his arm. He dashes about, among the pillars, peering here and there, until he notices the dancing girls, and his face is wreathed in smiles.

BANBO Kachi, kachi, kachi, kachi!

Clicking his teeth together in rhythm and, when the girls run toward him, he thrusts his face forward and opens his mouth wide, and roars like a wild beast.

 Aaaagh!

GIRL 1 What a disgusting old man!

GIRL 2 But he's not the least frightening.

BANBO Da, da, da, da, da! *(Laughing raucously.)*

 Well, being servants to the lady Princess Tomi, mistress of Himeji Castle, you naturally have such boldness that you do not so much as flinch in the presence of the reddest face in all of Oshu. You astound me with your unstinting resistance to ghosts. Announce me to everyone here.

GIRL 3 As an old codger who entered through the roof?

BANBO What a way to greet me! Just say I come from Inawashiro Castle. Come now, announce me, announce me.

	(Getting to her feet.) So I really must change clothes.
OMINAESHI	And, along with that, your hair also, My Lady...
TOMI	Oh, yes, so fix it for me if you will.

Tomi goes behind a door in the wall, followed by her Ladies-in-Waiting. The young girls remain behind, singing and dancing.

Where does this narrow path lead,
This narrow path,
It is the path to the Tenjin Shrine
This narrow path.

love-letter. Princess Yuki of the Demon Pond has both a violent and a refined side. The deep black clouds that made the field pitch black and the higher reaches on the mountain steeped in a lovely lapis lazuli here were both her work. This is all part of her promise to make the falconers unsteady on their legs, so that they left the pine woods behind and like the muddy river waters, they swept through the torrential rain under black clouds that ran through the sky above the blasted plain. Even where I stood, the sudden rain fell heavily, so instead of stopping to compose a poem, I borrowed this raincoat and bamboo hat from a scarecrow, and covered myself to make my way home safely. So I will just have the children, including Tonbo and Hozuki, return them later.

SUSUKI I really don't think there is any need for that.

TOMI Oh, but there is, for these are of great value to the farmers, so they must not be used carelessly.

SUSUKI That I do indeed understand, but, in any case, you really should change, as your robes are drenched and must be uncomfortable.

TOMI Thanks to the raincoat and bamboo hat, I did not get wet at all, neither am I uncomfortable. But even though we are intimate woman friends, it would be rude of me to remain dressed like this to welcome Princess Kame.

> The falconers gathered closely together around the roots of the pine tree growing as a signal on top of the mound in the midst of the rough plain, trembling like silver carp trying to hide in a muddy trough in a riverbed, while their straw hats swam out of reach and their battle cloaks flowed away off their shoulders. They let the swords at their hips get a little wet. And the family crests on their sleeves foamed and bubbled. There were even those who rolled up their trouser legs, revealing the moxibustion scars on their legs. How ridiculous they were! *(Grinning.)*
> Even the sparrows pecking at and devouring millet seeds are quieted by the sudden rain and settled down. On the other hand those men who stuff their mouths with five hundred, three hundred, one thousand bales of rice from their fiefs, were throwing into utterly idiotic confusion. Don't you agree that they were both ridiculous and pitiful?

SUSUKI · It is just as you say, indeed.

TOMI · On my way back home, I stopped at the foot of Mount Murasagi, and stood behind a rice-drying rack to gaze upon the scenery. There was a day-time moon, and it reflected on my sleeve as though it were a family crest. *(Placing her hand on her light-blue sleeve as she speaks.)* And that shadow looked like a neatly folded

out with a huge number of retainers to hunt with falcons amidst the autumn hills and dales.

And as you all well know, the migrant birds that fly high in the sky and the voices of the other many-colored birds make us happy to hear them, but the voices of the fief land birds and officers, who dash hither and thither, are raucous to the ears. And if it were only the falcons, I could put up with them. But these days, they make such a ruckus with their bows and arrows and rifles that their noise is absolutely unbearable, truly unbearable. But even more than that, my guest Princess Kame will come riding across the mist in the sky in her palanquin, so thinking that it would be rude to her on her way, I went to ask the Princess Yuki of the Demon Pond to scatter and disperse the falcon hunting entourage with deafening thunder and lightning and wind and rain.

SUSUKI
TOMI

So that was the reason for the unseasonable sudden rain. Was there only rain in this area? That was only a slight aftermath of the driving downpour. Just have a look at the Ichiri Mound in Himeji Plain where the falconers had gone out hunting, for there, black clouds filled the skies as though it were midnight, blinding lightning and earsplitting thunder flashed and even horrendous hail stones plummeted down on them.

(Taking off her straw raincoat.)
Please help me take it off.
Nadeshiko quickly gets to her feet, takes the raincoat and hangs it on the railing. Several butterflies rest their wings on the raincoat...
Tomi nods in greeting to the lion's head, seats herself in front of it, on a cushion and leaning on an armrest, that are provided for her by the anxiously attendant Ladies-in-Waiting.

 I feel a bit tired... Princess Kame has not yet arrived, I see.

SUSUKI Just so, but she will likely arrive soon. But even so, we have been eagerly awaiting your return...
But please tell us where you have been.

TOMI I went as far as the Demon Pond.

SUSUKI Oh, it is deep in the deserted mountains of Ono County in the Land of Echizen.

HAGI You went all the way to that Demon Pond...

KIKYO Just for pleasure...

TOMI Well, for pleasure, if you must call it that, but I had a small favor to ask of the mistress of the pond, Princess Yuki.

SUSUKI Both I and all these others are here, so we could easily have sent someone with a message, but you went out all by yourself, and got yourself rained on.

TOMI It was to request rain that I went... for, you see, from this Himeji Castle, the master of what looks like low class row-houses, the Lord of Harima has gone

hat in one hand that partially hides her face. She is the mistress of the castle, Princess Tomi.

TOMI *(Two or three butterflies follow after her, and when she reaches out from under her straw raincoat, they alight on her sleeve.)* Thank you so much for coming to meet and greet me. *(Speaking to the butterflies.)*

The Ladies-in-Waiting all bow low and speak words of welcome.

TOMI Once in a while, I get the urge to walk out into the fields. . .

She suddenly drops her bamboo hat. Ominaeshi catches it. Tomi has the face of an aristocrat, with extremely white skin, and she is quite elegant.

You who do not disperse the dew, what a pity for the shape of the blossoms.

(She descends and trailing her long skirt behind her.)

SUSUKI Oh, what a waste. . . for you to wear such a garment. . .

TOMI How does it look on me?

SUSUKI And on top of that, you have lost some weight. You look more gentle than a willow tree, and it makes you appear as though you have donned lemongrass thatching.

TOMI How you do lie! It is no more than a rag that I borrowed from a scarecrow in Oyamada.

SUSUKI Oh, but on you, it takes on the appearance of armor decked with precious jewels and platinum threads.

TOMI Your praise makes it feel quite heavy.

Upstage center, next to a round pillar, there has been placed an armor trunk, on top of which sits a lion's head with golden eyes and silver teeth, and indigo in color, and its hood is light green, attached to which is its spiral-shaped scarlet tail, giving it an overall grand and majestic appearance. All the Ladies-in-Waiting and the servant girls approach it and kneel to insert their blossoming branches into flower pots in homage to the deity. The lovely multi-colored flock of butterflies gather around the blossoms and dance about assiduously. Distant thunder is heard and it begins to rain.

SUSUKI *(Heard from the midst of the ensuing darkness.)* Just look, it looks as though its eyes are flashing threateningly and its teeth are moving.

KIKYO It seems to be enjoying both the blossoms and the butterflies, smiling in its joy.

Now and then there is a flash of lightning that throws rays of bright light into the room, and the butterflies are scattered about in their flight, but seeming to migrate toward a staircase that leads up through the high ceiling rafters. The Ladies-in-Waiting follow the flight of the butterflies, gazing upward toward the distant ceiling.

OMINAESHI Oh, the mistress has come home.

All of the women hurriedly arrange their clothing and bow before the dais, with their hands politely touching the floor. From the top of the staircase, the skirt of a light blue robe comes into view, followed by a long outer robe. Then a dignified, beautiful and proud woman with long black hair appears wearing a straw raincoat, holding a bamboo

SUSUKI A little while ago, both the fields and the mountains
 became strangely dark, and now a frightful rain is falling.
The stage darkens and lightning flashes.
NADESHIKO Where did our mistress go to visit?
 It would be so good if she would come back home soon.
SUSUKI As is her custom, she just went off somewhere on
 a whim without as much as a single word as to where.
HAGI And so there is no way that we can go out to welcome
 her home.
SUSUKI Since she is quite aware of the time that her guest
 Princess Kame is to arrive, I am certain that she will
 take that into consideration and come home before
 long. . . So everyone must come quickly and prepare
 for her welcome, and, first, it would be best to arrange
 and offer your blossoms to the deity.
OMINAESHI And particularly it must be done before the dew clears
 away.

KIKYO As you speak, the colors are hidden, and only the silver pampas grass flows along like pure white water.

KUDZU A dark cloud scuds across the sky.

So needless to say, Ominaeshi, the most politely silent of you all, has caught the greatest number.

OMINAESHI Oh, not so, for different from angling for fish, it is quite alright to raise our voices or even sing. . . It is just that it is no good if the wind rustles about. . . because that makes the dew bait dissipate.

Oh, I made a catch.

SUSUKI How laudable!

At this moment, Ominaeshi spins her spool, causing the thread to bring a branch of autumn blossom up to the railing. She hands it, along with the others that she has placed to her side, to one of the servant girls.

KIKYO I've made a catch.

(She spins her spool in the same manner.)

HAGI Oh, me, too. . .

Along with the blossom, a flock of tiny butterflies, colored yellow, white, and purple, flit upward.

KUDZU Look, look, me, too. . . Oh, how amiable!

SUSUKI Miss Kikyo, lend me your pole. I will also angle.

I am truly impressed and moved at such fineness.

OMINAESHI Wait just a moment. A strong wind has come up. The bait will no longer adhere to the threads.

SUSUKI How mean-spirited of the wind to suddenly blow with such violence!

HAGI Oh, the courtyard autumn blossoms are making lovely waves.

	but even though that means that you have time on your hands, you must not spend it frivolously.
NADESHIKO	But we are not angling for fish.
KIKYO	Since there are no flowers arranged before the Lord, we all decided that we would gather some to offer him, so it is flowers. . .
	those autumn blossoms, for which we are angling.
SUSUKI	Flowers, autumn blossoms, you say. Well, now, what an unusual idea! And have you caught anything?

She wraps her hand in her sleeve and places it on the shoulder of one of the Ladies-in-Waiting to peek over her shoulder.

KIKYO	Of course, we can make a catch, though this is our original invention.
SUSUKI	How you do brag. . . concerning which, I want to ask just to make certain, what is it you are using. . . in the realm of bait?
NADESHIKO	Well, you see, it is glistening white dew.
KUDZU	The myriad autumn plants and flowers long for plenty of dew at this hour, and since it is still late afternoon, there is not yet either evening or night dew for them. *(Looking to the side.)* And Ominaeshi has angled so very many already.
SUSUKI	Oh, indeed she has. So since it is autumn blossoms for which you angle, I will quietly observe you, for it is said that you must not converse while angling. . .

They nod innocently to each other as they excitedly mix their sleeves with the Ladies-in-Waiting.

SUSUKI *(Looking in all four directions.)* Oh, I must say,
 what a lovely view this is.
KUDZU That princess from Inawashiro is coming to pay a visit. . .
KIKYO And we thought that she might feel gloomy.
 Since the weather today is most amenable,
 and also because the leaves on the distant mountains
 are taking on autumnal tints. . .
OMINAESHI And the arrow-shooting and observation apertures are
 soiled with mud and iron shavings, giving them
 a heaviness, so we have opened their outside shutters.
SUSUKI Oh, I see, I see.
 As a way to avoid being lazy, it is impressive that you
 took notice and action on such a matter.
KIKYO Oh, my, that would put us in a bad light if it were to
 fall on outsiders' ears. . . why, when have we ever been
 negligent concerning such matters?
SUSUKI Well, what is behind these words of yours,
 and what do you think you're doing?
 As the saying goes, you seem to be trying to put drops
 in your eyes from the floor above you, for there is no
 way that angling can be accomplished from the fifth
 story of a keep. And the Celestial River will never flow
 over the turf. Princess Tomi is out visiting elsewhere,

to gold and silver rods that they are using as fishing poles with the threads hanging down among the branches of the surrounding tall pine and cedar branches. The three young servant girls, all dressed in red, continue singing, in very clear and lonely voices.

> Let them pass through, pass on through,
> Anyone who has no business here
> We will not let through, not let pass through
> Only those who come to plea with the Tenjin Shrine
> To grant their wishes, grant their wishes.
> Let them pass through, pass on through.

As they sing, they dance miming the lyrics of their song.
Susuki, appears from the wall of the castle keep. She is dressed elegantly with turtle-shell hairpins, as is befitting of a rather advanced age chief Lady-in-Waiting to the lady of the castle.

SUSUKI Miss Hozuki [ground cherry], Miss Tonbo [dragonfly]!
GIRL 1 Yes. . .
SUSUKI Play quietly, because we have just finished cleaning.
GIRL 2 Let's watch them fish.
GIRL 3 Yes, let's do.

SCENE ~ Fifth story of a castle keep, pillars on the right and left, corridors surround the left, right, and front sides, thick tatami mats with Korai cloth edging cover the center part of the floor space surrounded by heavy scarlet drum ropes with butterfly-shaped knots that also appear along the sides of the staircase that is upstage of the corridors on the right, to form a sort of railing. Staircase openings leading both upward through the ceiling and downward beneath the floor. Behind the right corridor, there is a thick wall with slender window-like apertures for shooting arrows and observation, outside of which can be seen a distant mountain range and a sky covered with autumn clouds. There is also a door in the wall. From the left-side railing of scarlet drum ropes, roof tiles and, those on the sides, branches of a grove of trees are also seen.
As the curtain rises, three of the small servant girls are singing.

> Where does this narrow path lead,
> This narrow path,
> It is the path to the Tenjin Shrine
> This narrow path.

The five Ladies-in-Waiting, Kikyo [bellflower], Hagi [bush clover], Kudzu [arrowroot], Ominaeshi [golden lace], and Nadeshiko [fringed pink], all dressed in kimono with patterns appropriate to their flowery names, are standing or sitting at the front railing made of scarlet drum ropes, each holding a different colored silk thread spool attached

TIME
Unspecified, sometime during the feudal period in late autumn,
from twilight to the dead of night.

PLACE
Himeji in the Land of Banshu,
on the fifth story of the keep of the White Heron Castle [Himeji Castle].

CAST
Princess Tomi, Lady of the Castle (appears to be 27 or 28)
Princess Kame of the Kame Castle
at Inawashiro in the Land of Iwashiro (about 20)
Zusho-no-suke Himekawa (young falconer)
Shuri Odawara and Kuhei Yamazumi
(retainers of Takeda, Lord of the Himeji Castle in the Land of Harima)
Shu-no-Banbo [priest with scarlet face] of Jumonji Plain and
Long-tongued Old Lady of Chino Plain (retainers of Princess Kame)
Toroku Omi-no-jo (wood carver)
Kikyo [bellflower], Hagi [bush clover], Kudzu [arrowroot],
Ominaeshi [golden lace],
and Nadeshiko [fringed pink] (five Ladies-in-Waiting)
Susuki [pampas grass] (chief Lady-in-Waiting)
Five servant girls
Numerous warriors and archers

Tale of a Castle Keep

by Kyoka Izumi
Illustrations by Aquirax Uno

translated by Don Kenny

Tale of a Castle Keep

All illustrations are drawn originally by Aquirax Uno and Takato Yamamoto
for Kyoka Izumi's Tale of a Castle Keep.
Copyright © 2016 by Aquirax Uno
Copyright © 2016 by Takato Yamamoto
Translation © 2016 by Don Kenny
Publishing © 2016 by Éditions Treville Co., Ltd.

All rights reserved. No part of this book may be reproduced or transmitted in any form or by any means, electronic or mechanical, including photocopying, recording, or by any information storage and retrieval systems, without permission in writing from the publisher. Printed and bound in Japan

Contents

Tale of a Castle Keep 3

Commentary Tamaki Anakura 93

Paintings 107

Old Tale -detail-

天守物語

Tale of a Castle Keep

Kyoka Izumi
Aquillax ウィツ

天守物語

Tale of a Castle Keep

Kyoka Izumi

Aquirax Uno

作 泉鏡花　画 宇野亞喜良

【天守物語】

初版発行　二〇一六年八月三十一日

作　　　　泉鏡花
画　　　　宇野亞喜良　山本タカト

翻訳　　　　ダン・ケニー
翻訳監修　　加藤めぐみ（都留文科大学准教授・英文学）
解説　　　　穴倉玉日（泉鏡花記念館）
企画・造本　窪田真弓、中井梓左、伊藤真以子（アップタイト）
編集　　　　川合健一
協力　　　　泉鏡花記念館　姫路文学館

発行者　　川合健一
発行　　　株式会社エディシオン・トレヴィル
　　　　　東京都渋谷区渋谷四-三一-二七　青山コーポラス八〇四
　　　　　郵便番号　一五〇-〇〇〇二
　　　　　電話　〇三-六四一八-五九六八
　　　　　ファックス　〇三-三四九八-五一七六
　　　　　http://www.editions-treville.net

発売　　　株式会社河出書房新社
　　　　　東京都渋谷区千駄ヶ谷二-三二-二
　　　　　郵便番号　一五一-〇〇五一
　　　　　電話　〇三-三四〇四-一二〇一（営業）
　　　　　http://www.kawade.co.jp/

印刷　　　シナノ書籍印刷株式会社
製本　　　株式会社常川製本

乱丁落丁本はエディシオン・トレヴィルにてお取り替えいたします。

ISBN 978-4-309-92095-5